# THE PHILADELPHIA STATE HOSPITAL AT
# BYBERRY

# THE PHILADELPHIA STATE HOSPITAL AT
# BYBERRY

*A History of Misery and Medicine*

## J.P. WEBSTER

THE
History
PRESS

Published by The History Press
Charleston, SC 29403
www.historypress.net

*Front cover, upper:* Crumbling second-floor hallway in C-4 building, 2005. *Photo by author.*
*Back cover, upper:* Panorama of C-10 building, 2004. *Photo by author.*

First published 2013
Second printing 2014

Manufactured in the United States

ISBN 978.1.62619.082.5

Library of Congress CIP data applied for.

The book you are about to read is the end result of my obsession with *Philadelphia State Hospital*. Compiling the following information was a labor of love for me, and it opened the doors of history to my prying mind.

This book is dedicated to all the staff at Byberry who cared about their patients. To the employees who worked long hours for low wages and hung on through intolerable conditions because no one else would, this book is for you.

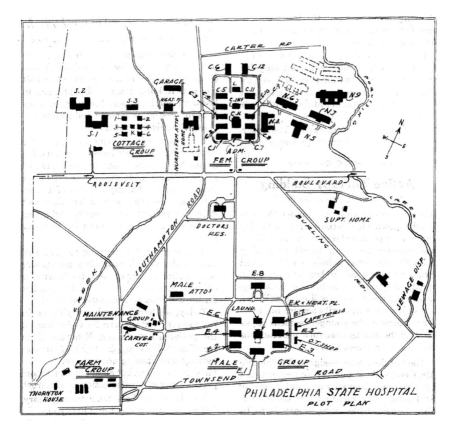

Plot plan of the 1,100-acre property, circa 1950. *Author's collection.*

# CONTENTS

Acknowledgements 9
Preface 11

1. Mental Healthcare in the Quaker City: The Origins of Byberry 15
2. The Blockley Colony at Byberry Farms: Philly's Funny Farm 23
3. Building Bedlam: The Crooked Construction Process 41
4. The Philadelphia Hospital for Mental Diseases: The City Years 51
5. The Philadelphia State Hospital: The State Years 87
6. The New Approach: Deinstitutionalization at Byberry 119
7. The End of an Era: The Closure of PSH 143
8. The Rediscovery of a Discarded Past: The Years of Abandon 157

Sources 163
Index 173
About the Author 175

# ACKNOWLEDGEMENTS

The author would like to thank the following for their kind assistance: Hannah Cassilly at The History Press, Hillary Kativa at the Historical Society of Pennsylvania, Margery Sly at Temple University Urban Archives, Jonathan Stayer at Pennsylvania State Archives, James Bostick, Dave Brown, Josh Morris, Bill Montgomery, Luke Papa, Ed Straddling, Gary Heller and my mother, Susan Webster (Philly's best teacher). And a special thanks to all the Byberrians—you know who you are.

# PREFACE

The first thing I noticed was the smell. Inching my head very slowly into an open window in N-10 building, I noticed that smell of abandonment. Mold, dust, wet insulation and stagnant air were not familiar odors to me. The November air was coarse and cutting, but I was sweating. The extreme quiet also produced an extremely uncomfortable feeling. The sound of the zipper on my backpack opening to remove my flashlight was like a startling electric guitar riff. "Sshhhh!" urged my friend Jay.

I shined my flashlight into the window, and it returned a bright flash from the glazed tile wall inside. It reminded me of my elementary school, the tile walls and echoing terrazzo floor. Turning the flashlight to the right, I saw another room through an open door. Lockers—it was a locker room. Anything could be behind those lockers, I thought, being very quiet and waiting for us to come inside. "You see anything?" Jay pressed. "Going in or what?"

He had been inside before. It was November 4, 2002, and a few days previous had been Halloween. The discussion came up about a haunted, abandoned asylum that was too scary for even the police to enter: Byberry. The Byberry hospital was the scariest place on earth, according to Jay. Byberry. I knew that name, that place. I remembered asking my father about "those buildings" when I was young, and his response: "Byberry, that's where they put the crazy people." There was an immediate reconnection in my mind to the curiosity his answer had stirred. Jay had agreed to go to the dark, desolate metropolis with me. He said he would show me around, and there we were.

It took me a couple minutes to make my way into the window—not because it was small or awkward, but because I was terrified. My feet hit the floor with a thud that echoed into thunder, at least in my ears. Jay had much less trouble entering. Those lockers, I thought, what's in those lockers? Before I knew it, Jay was out the door and down the hallway. I followed, but my flashlight only lit the way so far. The smell was worse now, the air thick and heavy. My steps seemed like hours apart, and the fear was gripping. The repeating, echoing sounds of Jay's footsteps and the jumpy glow of his flashlight were getting farther away. I whispered loudly, but he was off in the darkness. I tried to move faster down the hallway, but my legs just wouldn't move. Every step I took echoed into another sound altogether—booming, scraping. Finally, my flashlight found what looked like a stairwell.

Ascending the debris-covered steps, the evening sun did more to light my way. I saw what had to be years of graffiti in layers. Painted skulls, badly drawn pentagrams and words like "Satan" and "Metallica" brought the easing thought of contemporary youth—not so scary. But I also realized that the stairwell was encased in bars, whose layers of yellow paint were peeling in strange patterns and shapes. At roof level, a cell-like door was unlocked and ajar. It would have prevented roof access to anyone without a key. I was beginning to see how this place worked; it seemed similar to a prison.

Out on the roof, Jay was waiting. "What took you so long?" he jokingly asked. A feeling came on that was similar to the feeling I had after finally descending the high dive as a youth or finally learning to ride a bike. The view from the roof showed a layout of buildings, twenty-seven of them, all as empty as the night sky behind them. Jay picked up a half-filled can of spray paint laying on the roof and began writing graffiti on a wall. After catching my bearings, I asked, "Why did this place close?" Concentrating on his graffiti, he seemed to half hear the question. "They were torturing people in here," he mumbled. The answer startled me. "Huh? What do you mean?" Jay took about ten seconds to finish his tag and then he threw the empty spray paint can off the roof into the shadows. "My dad told me they used to torture the patients here," he replied, finally acknowledging the question. "Like...the dentist would pull out patients' teeth without Novocain, and the patients used to kill the doctors. But the guards would rape the women patients." Noticing the look of shock and awe on my face, he shook his head in an attempt to further dramatize the story. "They found so many dead bodies out here."

I slowly nodded, but at that point my doubts were too strong. "Really?" I asked. He looked at me and laughed, "Yup." But I didn't believe him. It was all part of the story, I thought. He must have gotten that from a horror movie. "Stuff like that doesn't happen in real life, dude," I said. That took true evil, not just unpleasant procedure. "Well, it's what my dad told me," he answered, no longer laughing.

After a while on the roof, the sun had gone down. We made our way back down the echoey hallway, past the lockers and out the window. Walking down the hospital roadway, I glared at the big, dark buildings as my eyes adjusted to the darkness. Another building came into sight. "That's N-9," said Jay. "We used to party on that roof." A lonely streetlight in the distance shone on a much larger and more imposing building. At ground level, another open window was pointed out by the streetlight—the only light I could see. We made our way to the window. I felt much more at ease and wanted to explore. I casually walked up with my flashlight and looked in the window. This time I let out a gasp. It was a dead deer, inside, on the floor. But it was black and green and red. It was covered in spray paint and had a rope around its neck. Its mouth was wide open, and I remember its white teeth. The fear came back and gripped me by the neck. It was about midnight now, and that feeling of accomplishment had been squashed. I just wanted to leave.

We began heading for the woods when the headlights of a small SUV swept across us. A security guard was making his rounds. We made a run for the nearby woods, tripping on brush and collapsing into thorn bushes. I felt the thorns rip into me, but adrenaline kept the pain away. We slowly peeked out of the bushes. He hadn't even seen us. Instead, the vehicle made its way over to the window revealing the deer. Under that lone streetlight, I could make out a man exiting the truck and looking into the window. I expected him to startle, as I did, but instead, he seemed to be laughing as he got back into the truck and drove away. Hmmm, must have been a deterrent, I thought, a good way to keep the neighborhood kids out. But I had never been more intrigued by a geographical location.

The large group of threatening, dark buildings bordered closely by a busy neighborhood seemed very out-of-place indeed. Never having been afraid as a child to explore, climb, crawl and bushwhack my way into unknown territory, now at twenty-four, these buildings genuinely frightened me…and I loved it. I quickly became obsessed with Byberry—the physical character of the buildings, the placement of the windows, the graffiti everywhere, that unforgettable smell, the unsettling darkness except for where a few

still-functioning street lamps beamed circles of yellowish light onto the institution's overgrown roadway. There was so much about the place that fascinated me from the start. As fate would have it, I would come to find out much more about Byberry and about what made it one-of-a-kind.

# MENTAL HEALTHCARE IN THE QUAKER CITY

## *The Origins of Byberry*

### BYBERRY

Byberry, an area of about three miles square, is a neighborhood in the northeast section of the city of Philadelphia. It is today the northernmost section of the city, and it was settled before William Penn's proprietorship actually began. In 1667, four brothers from England arrived on Pennsylvania's shore in the present-day city of Chester, then occupied by Swedish colonists. They set sail upriver again until they reached the mouth of the Poquessing Creek. Following the Poquessing, the brothers finally settled in what is today part of Philadelphia's Thirty-fifth Ward, Byberry. These were the Walton brothers. They were Quakers looking for a place to live and practice their Quaker religion freely. The Waltons gave their new home the name of their old home in England: Bibury. Over the years, the spelling has evolved into "Byberry."

Before the onset of the French and Indian War, Byberry was part of an area that made up what was called Smithville, one of many towns in colonial America named for Captain John Smith. In the last half of the eighteenth century, Smithville became known as Moreland Township, which later split into upper and lower halves. The population of Byberry was primarily Quaker. There was a powerful underground railroad in Byberry too. It was the home of Robert Purvis, staunch abolitionist, who built Byberry Hall in 1846 and frequently held antislavery meetings there.

It still stands next to Byberry Friends Meetinghouse. The Consolidation Act of 1854 absorbed Byberry into the city of Philadelphia, but its inclusion almost didn't happen. The area consisted mostly of families who had lived there for over a century. They enjoyed small township tax rates, and they knew what would happen as a result of being absorbed by the rapidly growing city: a huge tax hike. Despite their opposition, Byberry became part of the city of Philadelphia.

## THE BIRTHPLACE OF AMERICAN PSYCHIATRY

There is little doubt that Philadelphia is probably the most "American" of American cities. Its founding epitomizes the European idea of what the New World had to offer. One of the newer of the thirteen colonies, Pennsylvania was conceived and planned in England and merely laid out in America. By 1681, the layout of William Penn's "Holy Experiment" had been imagined and drawn out. This seventeenth-century city already provided everything Americans have come to know as the "American Dream." Its lots of property were already laid out from river to river and featured up-to-date houses constructed in the row-house layout, evenly distributed around public squares. William Penn's new city would introduce the rest of America to a way of living that, in many aspects, still exists today.

Like any public municipality, Philadelphia has had its share of public health problems. But unlike most, it paved the way for America's method of dealing with these problems. The first public hospital in the United States, the Pennsylvania Hospital, was founded in 1751 and is still in operation at Seventh and Pine Streets. The colonial city was home to several pioneers in the medical field. Dr. Thomas Bond performed the first lithotomy (removal of kidney and gall stones) in the new world. He was world-renowned for his brilliant medical abilities. Dr. Philip Syng Physick earned the moniker "Father of American Surgery" for his work at the Pennsylvania Hospital.

Benjamin Rush was born in Byberry in 1741. He was a signer of the Declaration of Independence and the "Father of American psychiatry" and was the first in the country to treat mental diseases as a medical condition. He was also fearless during the yellow fever epidemic in Philadelphia in 1790. He was one of a handful of doctors who stayed in the city and worked tirelessly at what he believed to be a cure. His method of bleeding and purging was used frequently on hundreds of

patients. Rush's belief that most diseases were blood-born caused many a patient to die as a result of bleeding and purging. Rush is still regarded, however, as a pioneer in the field of American mental health. His ideas paved the way for the American "asylum."

Psychiatric care in most of colonial America was practically nonexistent. Philadelphia was the largest city in the thirteen colonies, and naturally, it was full of men with big ideas. Fortunately for most Philadelphians, the idea men of their city were largely philanthropic. The Pennsylvania Hospital started as a free hospital and only charged those who could afford to pay. But as the city got bigger, so did its troubles. The hospital was forced to begin charging every patient for care, and the ward for insane patients was moved to the basement. There they had the unwanted opportunity to be strapped into Dr. Ben Rush's "tranquilizing chair," where they were deprived of their senses for hours at a time.

Another of colonial Philadelphia's public options was the almshouse. A Quaker conception, the almshouse was a place for the poor, sick, widowed and "pitied" citizens of Philadelphia to receive shelter, food and sometimes-mediocre medical care. But that was a time when the people of the city were fewer and its undesirables easier to manage. The taxpaying colonists' new system was working well. But the attractive city in the New World was looking good to many others in Europe and elsewhere, and the foundation would only hold for so long. By 1800, the crowded seventeenth-century almshouse was proving inadequate for the waves of poor immigrants flooding the city.

## The New Almshouse

At the close of the Revolutionary War, the city was filled with mostly middle- and lower-class revolutionaries. The wealthy Loyalists and Tories fled the city after Cornwallis's defeat, fearing execution. The pacifist Quakers, who mostly had chosen to remain neutral in the war, now found themselves without much power in Philadelphia. The new capital was run by men who took chances and made sacrifices. During the hustle and bustle of the years as the nation's capital, Philadelphia saw little progress in the way of medicine or public health.

Not until the 1830s had the Quakers regained some of their hold in the city. A brief period of considerable advancement, the decade and a half

prior to the Civil War saw the fruition of Quaker ideals into physical form, such as the penitentiary and almshouse. Construction began in 1821 on the Eastern State Penitentiary, the first of its kind in the United States. The idea of reforming a prisoner through penitence and spiritual enlightenment was the prevailing conception. This was the first time prisoners were thought of as "curable" and not simply morally sinister. For most crimes—including, in many cases, murder—if a prisoner could afford to pay his fine, he was simply released. The fearful-looking new penitentiary would revolutionize the country's attitude toward crime and punishment.

Meanwhile, the old almshouse on Pine Street was overcrowded and completely insufficient. It was meant to offer beds only to non-able bodied patients for a short time, not house them permanently. But by 1830, the almshouse was home to almost two hundred insane males and females together with sufferers of contagious diseases, destitute homeless and orphans. It was clear the growing city needed a new almshouse for a quickly evolving population—one that would be large enough to contain sufficient space for all the classes of illness it would treat.

In 1831, a site for the new almshouse was chosen outside the city boundary across the Skyulkyll River in Blockley Township. It afforded plenty of room for a large structure. In 1833, the Philadelphia Hospital accepted patients from the Pennsylvania Hospital and the old almshouse. By 1841, it housed over eight hundred patients. The new almshouse was seen as more of a hospital, able to treat and release patients on a steady basis. Unfortunately, it would prove to be more of a warehouse for permanent residence of thousands of lost souls who managed to filter down into it. Admission, in most cases, was a last resort for patients who had proved uncontainable in other hospitals. The Philadelphia Hospital, its official name, would become known simply as "Blockley," and its reputation would become infamous.

Blockley's designer, William Strickland, took care to include every modern feature. It contained wooden pipes taking in water from the Skullkyll River. Its grand façade gave the look of permanence and safety. Featuring four rectangular buildings connected on the corners, the hospital formed a giant square. In the center of the square were courtyards that contained greenhouses, athletic areas and a central fountain. Each of the four wards pertained to a different class of treatment. The males and females were separated on opposite ends of the hospital.

# A History of Misery and Medicine

## Philadelphia's Public Health Problem

Throughout the nineteenth century, the Quaker city was cliquish and parochial. Its citizens were black and white, rich and poor, and its governing body was not unlike that of other cities. The "us and them" mentality was prevailing. America feared anything that it didn't understand. Mental illness was only one of the many stigmas America placed on its citizens. As a result of this social system, the almshouse began to take on its own stigmatism. It became the place for any and all of the city's discarded citizens. This was the birth of Philadelphia's biggest public health problem: the overcrowding of its public facilities. The hospitals and houses of betterment built by the city were, by nature and forethought of planning, charitable and heartfelt causes. But the overcrowding presented other problems in itself, and neglect and abuse was the result. Overcrowding would prove ultimately fatal to Philadelphia's public health system.

At the close of the Civil War, a middle-class Philadelphian would have had no shortage of access to medical care of all kinds. There were many medical hospitals throughout Philadelphia County, as well as several asylums. The mentally ill, depending on social class, actually had some of the best options in the United States. The Friends Hospital for the Indigent Sick-Poor was one of the first hospitals in the country built for the care of the mentally ill, but it was not free. The Pennsylvania Hospital still offered care to mental cases, but also for a price. Thomas Kirkbride's Hospital for the Insane in west Philadelphia, built in 1856, was another option. A charity hospital, Kirkbride's offered decent custodial care. As superintendent, Kirkbride's strict methods of "moral treatment" did not allow the hospital to become overcrowded, and the generous donations the hospital ran on ensured that it wasn't understaffed.

The Consolidation Act of 1854 was a move by the city's elite politicians to ultimately gain more votes by bringing more voters into its wards. It expanded the city of Philadelphia from 8 square miles in size (the Delaware river to the east, Schuylkill river to the west, Vine [originally North] street to the north and South street to the south), to its current size of 135 square miles by combining city and county. The farmers who lived in Philadelphia County's northern and western townships did not want to pay city taxes. But as fate would have it, every township in the county was consolidated. This meant that Blockley was no longer in the "outskirts" of the city. The rise of the railroad brought steady traffic through what was once farmland in west Philadelphia. Blockley became harder to avoid as new houses and factories sprang up around it.

## BLOCKLEY DAYS

The sixteen-acre structure, which contained within it a smallpox hospital, a lunatic asylum, a children's home, a lying-in department, a nursery and a medical-surgical hospital, was run by the Gaurdians of the Poor. A parent of the Department of Public Charities, the Guardians of the Poor became known as the "board of buzzards." It was made up simply of unelected businessmen and wealthy, influential citizens who took up the cause of helping the city's paupers. But often its members seemed more interested in helping their own reputations. They soon earned their nickname, as stories of their shady dealings began to circulate and Blockley became more notorious.

By 1858, the hospital's hideous conditions had been in the headlines enough times to inspire reform. It had become commonplace to sell off dead patients to medical students, who paid handsomely. A legislative act supposedly put an end to the trafficking of corpses by the end of the Civil War, but the practice continued. One superintendent defended the sale of the dead, claiming the hospital received more funds from that than it did from the city. An 1870 investigation into the hospital's conditions revealed a large amount of whiskey stored in the hospital's basement. The superintendent claimed it was used to keep the dead from decaying as quickly in the summer months. The public was stewing. The University of Pennsylvania's move to West Philadelphia in 1871 was another hindrance to the city government in its attempt to hide conditions at Blockley.

In 1882, after the resignation of then superintendent Major Phipps, it was discovered that Phipps had been defrauding the city and the hospital of thousands of dollars. He helped himself to portions of employees' wages that he was in charge of dispersing. In some cases, even patients' property found its way into Phipps's pockets. A police search of his Walnut Street home turned up $5,000 worth of hospital property stored away in his basement, but no Phipps. He was finally apprehended almost seven months later in Hamilton, Ontario, and returned to Philadelphia for trial. The trial of Major Phipps brought many more injustices to light, and other hospital staff were removed or arrested. Another reorganization was undertaken, and the top staff were almost all replaced.

Similar conditions were reported in other institutions. Hospitals and asylums of all sorts—public and private—throughout the state were examined. However, more time and money were given to Pennsylvania's taxpayer-run facilities. In 1887, the state legislature passed an act that

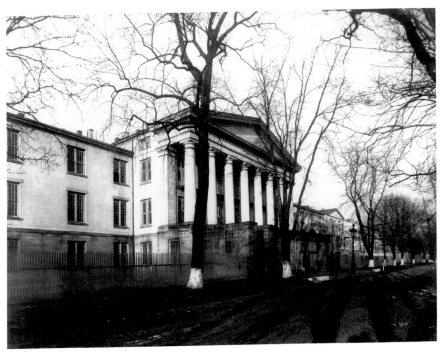

Blockley Almshouse, front façade. *Historical Society of Pennsylvania.*

officially reorganized its public health system: the Bullitt Bill. The bill essentially brought the state's disorganized system of public institutions into the civilized age and established basic steps toward a modern system. Named for the senator who created it, the bill called for, among other things, a "Board of Charities and Corrections." Although a single city municipality, the two divisions of the board were controlled by rival ward bosses, and a schism was already forming. The Board of Charities was in charge of all public hospitals and asylums, and the Board of Corrections was responsible for the prisons and jails. What resulted was the constant shuffling back and forth of dangerous mental patients between the prison system and almshouse.

## A NEW CENTURY

Philadelphia rang in the new century with pomp and pizazz. On January 1, 1900, the nearly complete city hall tower was decorated by hundreds of

electric lights. The Mummers marched up Broad Street for the first time in their parade. The Ancient Order of Elks and other fraternal organizations held symbolic ceremonies. Philadelphia was proud of itself. Only recently having been surpassed by New York City as the nation's largest exporter, it was still very much a world-class city. Its political force was beginning to emerge as a national powerhouse. Philadelphia lawyers had for decades been known throughout the United States as some of the best, and the city government still consisted of factions of elite businessmen who, in most cases, were loyal more to their businesses than their political careers. For these figures, the Victorian period in Philadelphia was a very productive and profitable one. It made millionaires of middle-class men.

At the turn of the century, Philadelphians were full of excitement, angst, regret and remorse. The bustling city was never more alive...or crowded. Public health was becoming more of a concern as more diseases and health threats were discovered. The city did its part to keep a clean and healthy environment for most. Classes of citizens multiplied. A few got rich, but the poor stayed poor or got poorer. Simultaneously, the city was showing off its expensive, modern examples of urban progress. The new Spring Garden sewage disposal plant was an example of a government that took steps toward better health for its citizens.

The new Torresdale Filter Plant, when completed, would provide clean water to almost half the city. But behind the curtain, there were flaws. As the population grew, the city's public institutions were bloating. Ironically, while some of the biggest advancements in medical science were being discovered at the University of Pennsylvania and Jefferson Medical College, the city's public institutions offered mediocre medical care. Blockley's conditions continued to deteriorate as the number of its patients doubled and then doubled again. By 1902, the institution was in the middle of a thriving and growing urban neighborhood. Its presence became a real threat to the surrounding area. A new place to hide the stigmatized insane of the city was clearly necessary.

Chapter 2

# THE BLOCKLEY COLONY AT BYBERRY FARMS

## Philly's Funny Farm

### THE DPHC

With Philadelphia's population rising every year, it was clear that overcrowding was its number one public health problem. In 1903, amendments were made to the Bullitt Bill to allow the Department of Charities and Correction to split, creating two separate departments. It also required each county to erect new hospitals for each of its newly formed classifications of social medicine. In Philadelphia, the effect was the compartmentalization of the city's departments, which ultimately spread thinner its ability to successfully supervise them. The newly created Department of Charities was, for a short time, an independent department. It soon merged with the Department of Health, ultimately creating the Department of Public Health and Charities (DPHC).

Throughout most of the commonwealth, sharing the cost of public care with the State helped a great deal. Philadelphia however, being the most populated county, dealt with the most turmoil. Under the new system, the Department of Health and the Department of Charities were still two separate entities that were merely funded as one. The Department of Health controlled the state's public medical hospitals, which accounted for about two-thirds of its budget. The Department of Charities controlled what the State considered its "charitable" institutions—hospitals for the insane, the indigent, the "pauper type." Although under the same umbrella, the two departments were not above political sibling rivalry.

Efforts by the City to get more support from the State began in 1904 and would continue until 1938. However, the rerouting of the funds the State did provide—and the fact that some always found its way into the pockets of the city's corrupt elite—did not encourage the State to give more. The fate of Philadelphia's indigent and insane was tossed and shuffled around during the battle that ensued as reformists, the city's elite and the State all duked it out over how much funding Philadelphia should receive from the commonwealth. In the end, the elite won, and the State's funding remained moderate enough for them to skim from it with little conspicuity.

To understand the story of Byberry, it is important to understand the governing body that created it. As a presence in the city since before the Civil War, political corruption was nothing new to Philadelphians, but the laws and general practices of the city government made it inevitable that new cliques would form as technologies were born and new industries blossomed. The elite players in city hall did battle over the city like a chessboard. The new public hospitals were, like many other projects, pawns to these players. The Republican faction that ruled Philadelphia at the turn of the twentieth century gave the whole country a lesson in graft. The key figures who made up that faction became known as the "the Gang." Led by the hardened Philly powerhouse Israel "Is" Durham, the Gang had complete control of the nation's third-largest city.

## Gangster Government

Israel Wilson Durham was born in Philadelphia in 1856. A man who appreciated personal connections, Durham worked as a bricklayer until he was elected a judge in 1885. Through his judgeship he made more connections. In 1897, he was elected state senator and thus began building himself an empire in Philadelphia. By the time he was succeeded in the senate by Boise Penrose in 1899, Durham had a firm hold on the City of Brotherly Love. Headlines joked of how the city could not function if Durham was not in town. But as more Philadelphians came to learn, these were not jokes. Mayor Samuel Ashbridge, whom Durham got elected, was merely a puppet. It was rumored that upon his election, he was not allowed to enter the mayor's office until Durham had finished an "important meeting" there. Durham's reputation as "the boss" was clearly solidifying. In 1900, Durham took the position of insurance commissioner, which allowed him to remain

mostly in the backdrop of the political stage while he ran Philadelphia as the leader of the Gang.

Middle-class Philadelphian Philip H. Johnson was working for the city's Department of Engineering as a rodman when he met Durham's youngest sister, Margaret. Johnson married Margaret in 1902 and was thus interred into the Machine. As his brother-in-law, Durham saw to it that Johnson would make a good living for his sister. He gave Johnson the lifelong position of city architect through a "perpetual contract." On March 30, 1903, Mayor Samuel Ashbridge signed the contract, sealing the fate of Pennsylvania's public hospitals, as Johnson would be guaranteed the job for the rest of his life. Johnson was a perfect choice for the Gang. He had no problem taking payoffs from contractors or using cheap, out-of-contract building materials and labor to cut costs. His blatant acceptance of payoffs and attempts to muscle landowners and subcontractors out of their share of profits made him a known accomplice of the Gang. During his position as supervising architect of the new state capitol in Harrisburg, his several subpoenas and eventual testimonies in court made headlines. The construction of the capitol ended up costing the State more than five times the original estimate. The State received bills such as $200 for a doorknob or $500 for a "new electric light-bulb." The outnumbered reformists in city hall and in Harrisburg tried time and again to get to the bottom of the corruption, but as the Durham Gang's official architect, Johnson was untouchable.

In the midst of the new legislature, the Gang's reach extended into almost every department. From its inception, the new system of public health began to spoil in the hands of its executors. The mayoral term of Samuel Ashbridge was known to Philadelphians as the "Reign of Ashbridgism." During his term, several important events occurred. Ashbridge pushed through Johnson's eternal contract, leaving the mess for the next man to clean up. In 1902, Durham chose John Weaver as mayor. Weaver and Durham had been longtime friends and business partners, and Durham was sure he could puppet Weaver as he had done other mayors for twenty years. But in 1904, Weaver turned on Durham and exposed his corruption and history. After a bitter legal fight, Weaver succeeded in expelling Durham from politics. Durham moved to his summer home in Atlantic City for the last four years of his life. He died in 1909 during a luncheon and was buried at Mount Moriah Cemetery. But even after Durham's death, Johnson held onto his "perpetual contract."

The city's original idea was to erect its new insane asylum on land it planned to purchase just north of the new Torresdale Filter Plant, on the

city's extreme northeastern border. This tract—the Brown tract—included the area south of Glen Foerd Mansion. This plan, however, turned out to be too costly for the city and did not afford the necessary space required to build a decent facility, not to mention its proximity to the developed community of Holmesburg, which contained over eight hundred residents at the time. Holmesburg residents voiced their concerns to the mayor. Already unhappy about the new House of Correction the city erected in their neighborhood, they were not about to allow a mental hospital to be built. The grueling battle over where to erect the new hospital began.

Under the Weaver administration, new policies were enacted and many old ones were overturned. Weaver was determined to solve the Blockley problem, but most of the successful construction firms in the city were members of the Gang and worked against Weaver's attempts at reform. However, under Weaver's direction, the city purchased the Townsend tract in Byberry for use as the County Prison Farm, an inmate-run farm for the supply of vegetables for most of the city's public institutions. The Townsend tract consisted of approximately 350 acres of farmland that bordered the Poquessing Creek to the north. Inmates from the House of Correction were utilized, and the "chain gang" worked the fields. The first inmates began work on the farm in 1906. It soon became known as Byberry City Farms. The vegetables and other produce harvested by the inmates were sufficient to provide for all the city's public institutions, as well as some private buyers.

The first director of the Department of Public Charities, Dr. William Coplin, stated in a report to Mayor Weaver that the Byberry tract "is splendidly located, well suited to farming and possesses a surface contour adapted to the erection of buildings for the reception of the insane at present crowded into the insufficient space afforded by antiquated buildings long out of date and no longer capable of alteration to meet modern requirements." Debates over how to split the cost—combined with the still mostly Gang-loyal city officials dragging their feet—put the Byberry purchase on hold. Weaver, suspecting ulterior motives in the delay, took a trip out to Byberry himself to promote attention. Weaver must have been impressed. Immediately after his visit, he urged the city to purchase more land in Byberry. After pondering the advice of state officials, the city finally caved and a motion to purchase the land was presented to council. The city had no problem getting the land for a good price by buying out farmers who had grown tired of their increasing tax rates. All but two council members seemed in favor of the ordinance of $261,000 for the purchase of the land. Arguing for a site closer to Blockley, these two managed to hold up the purchase yet again. Mayor Weaver was

anxious to acquire the land before the price went up. Nowhere in the city could be afforded such vast stretches of open land. Weaver sent a letter to the two members who were against the purchase. It read, in part:

> *In the matter of the purchase of the site at Byberry for a new insane hospital I am told that there is a rumor that you intend to oppose the ordinance. Of course if you do you will have some good reason for it, and it would then be your duty to do so. I ask you however, not to permit an opportunity to go by for the city of Philadelphia to get large tracts of land at a reasonable figure unless you can give the city something as good for as reasonable a price. It is such a marvel that the city should have a piece of property offered at a reasonable figure that I think we ought to jump at it. I do ask you, however, to keep in mind the poor insane in the charge of the city, and crowded into the inadequate quarters at Blockley.*

The letter did little to change their minds, as the two still voted against the ordinance. But an overwhelming majority ruled in favor, and the money was approved. Meanwhile, the doctors at the insane ward at Blockley, headed by Chief Physician W.W. Hawke, slowly began pushing back against the Gang-controlled prison board that had dumped hundreds of violent inmates from the House of Correction and Holmesburg Prison into Blockley's wards. It seemed that the new DPHC and the old, Gang-controlled Department of Corrections were doing political battle over old gripes. Hawke advocated for more space at Byberry for Blockley's patients, insisting that sending them out to the farms was the best way to relieve the bursting, eighty-year-old hospital.

## Phil Johnson and his Wonderful Job

In 1905, the Weaver administration tried unsuccessfully to oust Johnson from his position. Weaver was a sidekick of Durham's and had watched Johnson come from nothing. Weaver knew all about Johnson's "contract." By exposing to the courts some of the illegal methods the Gang used, Weaver painted a vivid picture. For instance, he called attention to the fact that Johnson acted as inspector at his own job sites. Although adding a few new stipulations, the courts held up the Johnson contract as unbreakable, and he emerged with his title of city architect intact. One new rule of the contract was that a non-partisan, third-party inspector was to be hired to supervise the job sites.

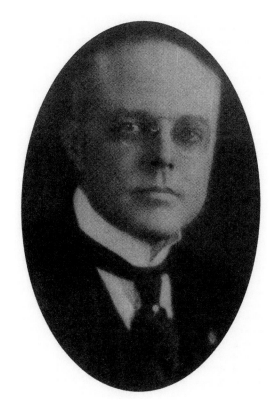

Architect Philip H. Johnson, 1931. *The Athenaeum of Philadelphia.*

He was to be chosen by a committee of architects and was to submit his reports to them. Easily quashing this obstacle, Johnson had his friend and fellow Gang-man James Finlay appointed to the position, assuring cooperation.

Backed by his friend and DPHC director Wilmer Krusen, Johnson became somewhat of a bully to most architectural and construction firms in the region, and he was dreaded by most who were involved in Philadelphia politics. Construction firms and local architects learned that they basically had to pay Johnson to un-involve himself from their projects, and rarely did anyone cross the Gang. Johnson became a wealthy man in a short time. He joined the Philadelphia Yacht Club and purchased a $20,000 yacht. His status as a yachtsman grew, and Johnson became the club's commodore. He appointed his brother Orlando "Orrie" Johnson as vice-commodore. As his career flourished, his political connections grew.

Weaver succeeded in getting the land purchased. Had he remained for a second term, the first years of Byberry might have turned out differently. Under his administration, the purchase of the Keigler, Mulligan, Kessler, Jenks, Grub, Tomlinson, Osmund, Carver, Alburger, Updyke, Comly and Carter tracts made up the 870-acre site for the new hospital. By 1913, the additional purchases of the Stevens, Dyer, Bening and Worthington farms would bring the total acreage to 1,100. The farmhouses and barns that came with the land purchases, some centuries old, were all utilized for housing patients. Aside from a few minor additions and repairs, these houses were

mostly original and did not provide much security. Soon after the purchases, one hundred patients from Blockley were sent to work at the farms and live in the houses. Escapes were almost immediate, but lost in the open farmlands of northeast Philadelphia, most patients did not get far.

## FARM THERAPY

Patient labor accounted for much of the work done to the old farmhouses. The Kessler House was painted throughout and received a large addition containing offices and a private dining area for the chief farmer and the resident physician. It became the administration building for the farms, though only for a few years. The Jenks House was repaired, painted and insulated. It was used as a winter home for patients. The Jenks Tenant House was largely renovated, and heating was installed. Two wings were added onto the sides of the house, making room for 60 tubercular patients. The Kesslers' wagon house was converted into a large dining room for 150 patients. A range was installed, and the building's porch was enclosed in glass. The second floor accommodated 40 patients as a sleeping quarters. The Osmund House was re-shingled, painted and converted into a dormitory for 40 "mildly insane" patients. More than half of this work was done by the patients. They built roads and fences, planted trees and did much to beautify their environment. They are probably also responsible for constructing the additions to the Hoseington House, which sat on the north side of Burling Avenue, near Townsend

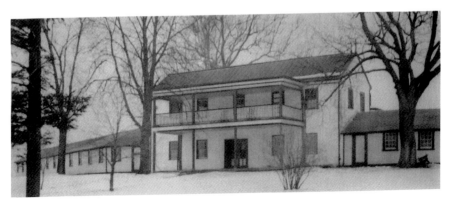

Hoseington House. *Temple University Urban Archives.*

Interior of Kessler's wagon house, circa 1938. *PhillyHistory.org*

Road. The eighteenth-century farmhouse was flanked by two wood-frame wings containing another 150 beds.

The Gang regained control of city hall when they were able to elect John Reyburn as mayor in 1908. Reyburn discontinued many of Weaver's reform policies, and the fate of the patients at Byberry Farms was once again in the hands of corruption. Accompanying Reyburn's mayoral term was the appointment of Dr. Joseph S. Neff as director of the DPHC. Neff took a keen interest in the idea of using the Byberry Farms as a spill-off for Blockley. Under his direction, the first fifty insane patients from Blockley were sent out to the farms. Aside from a few escapes, the majority of the patients showed an "improved condition," and the solution to Blockley's overcrowding was now clear. Dr. Neff advised the removal of more types of cases out to Byberry. It was located twenty miles from the city proper and was the most rural area within its boundaries. The term "funny farm" originated from the fact that almost all mental hospitals or asylums had been constructed in the middle of endless farmland, far away from the cities they served.

In 1908, the city erected its first official building at the farms, the Tubercular Pavilion. Designed by Johnson, the pavilion was a frame building that sat about three feet off the ground on concrete slabs and had a capacity for eighty patients. The new pavilion was located just north of Southampton Road, near the Carver house. Meant only as a temporary structure, it was a true nineteenth-century epitome. Made of wood, it featured a stone chimney above a coal-burning iron furnace, and even by 1908 standards, it was a firetrap.

The reformists found a new ally in Rudolph Blankenburg and managed to get him elected mayor in 1912. Under the Blankenburg administration, Dr. Alexander Wilson was named assistant director of the Department of Public Charities. Working closely with Dr. Neff, Dr. Wilson developed what became known as the "Colony Plan." It was an experiment to see if milder patients could "cure" themselves through farm work and fresh air, but to the city, it was a way to save money on labor costs by having patients work on the farms, as well as making more room for chronically insane patients at Blockley, and the experiment yielded excellent results. The colony plan was fairly simple.

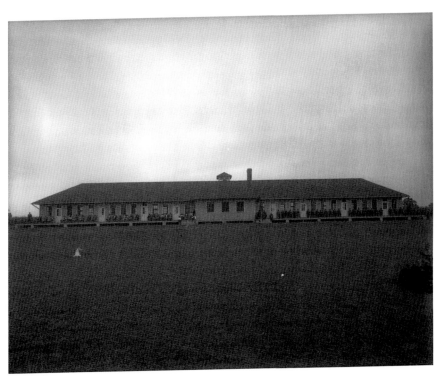

Tubercular Pavilion (building J), 1909. *PhillyHistory.org*

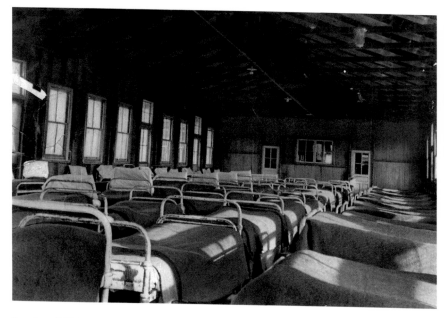

Interior of Tubercular Pavilion. *Historical Society of Pennsylvania.*

Each of the old houses was a colony, and there were approximately twenty-five patients living at each colony. Placed in charge of each house was a man and his wife, the latter acting as a matron who looked after the basic needs of the patients. However, it is not clear if these couples were employed by the City or the DPHC, or employed at all. It is also not known whether they had any medical training, let alone training in the field of care for the insane.

Each of the properties and the houses and barns they contained were put to use for a different purpose. The Jason Tomlinson tract, near the present-day intersection of Thornton and Townsend Roads, was used as the Farm Group. Its existing cow barn and chicken shacks were utilized, and new grain silos were erected. The farm group contained all of the institution's farm implements, as well as quarters for the chief farmer and his assistant. The properties of Richard Cripps and Wilmer Tomlinson, just north of the Jason Tomlinson tract, were used as the maintenance group, which housed the power plant employees and the repairmen on staff. The new colonies at the farms did not receive much attention from the public, which was most likely the desired effect. As the population grew, the patients themselves continued fixing up the old houses. By 1910, there were 282 patients working on the farms, and they had produced a net profit of $30,309.26 for the city. Some city officials predicted failure as the flow of patients got heavier each year.

## Who's in Charge Out Here?

In 1912, the DPHC formed a subcommittee to inspect the facilities under its care. Two representatives of the committee, commissioners Ralph Blum and George W. Ryon, visited Byberry on May 23, 1912. Upon their arrival, they were met by assistant resident physician Dr. Edward A. McClain and chief attendant of the tubercular unit Dr. W.J. Deeny. Dr. McClain stated that there were twenty-eight attendants on staff for 281 patients and pleaded to the members for additional funding. During their tour of the property, Ryon and Blum came to understand McClain's distress. The 17 tubercular patients on the farms were not receiving fresh air at all. Huddled into the Jenks Tenant House most of the day due to lack of attendants, they wallowed away in the midst of the open fields that were supposed to heal them. As the inspectors wandered the grounds, they found more and more unhealthy conditions. It became apparent that there was no real faculty or person in charge at all. McClain only tended medically to the sick, he stated, and did not know of any administrator.

The inspectors found that three of the cottage houses were lit by gas lamps, an obvious fire hazard. In the Grubb House, they saw windows with a few slabs of wood hammered in place over them as a way to prevent escape. The Mulligan House predated plumbing and had no toilet facilities. Its twenty-seven resident patients used metal buckets. The Tomlinson House had a flooded basement that was unusable. It was discovered that laundry was done by patients in creek water. The storehouse was full of holes, resulting in losses of the food supply to rats. The milk was infested with flies and usually not safe for consumption.

Ryon and Blum, when inquiring to McClain about the day-to-day activities of the patients, were referred to a Mr. Freemont Bowman, the chief farmer. Mr. Bowman was apparently in charge of all of the purchasing and distribution of funds for the farms. "All I can do is ask Mr. Bowman for supplies," stated McClain, "and if there are none to be had, then the patients have to do without them." McClain's odd response led the inspectors to inquire as to Mr. Bowman's whereabouts. McClain referred them to a large tract of land just south of the Byberry Farms property. When the inspectors arrived at his home, they were startled to see a large and lavish house, a stark contrast from the farmhouses occupied by the patients. Bowman, not surprisingly, was unavailable for comment.

The Ryon/Blum report recommended that a full-time, well-paid superintendent should be hired, as well as more attendants. The tubercular

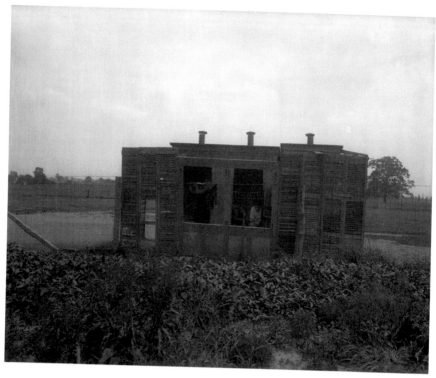

Outhouse at the farms, 1912. *PhillyHistory.org*

pavilion, they said, did not meet any of the requirements of a TB facility. They recommended several of the houses be torn down and new buildings erected. It seemed from Byberry's first inspection that nobody cared about it. Sadly, this would become the status quo. Right from the first, inspections became routine. But no matter how many bad reports came in, the Gang always managed to shift the focus off their garden of graft. They had affiliates in almost every department of city and state government, and often through impressive political manipulation, the Gang always managed to avoid taking a hit. Byberry had had its share of sincere reformers from the beginning, but it was next to impossible to create waves in the system that were not quickly smoothed out internally. Inspectors never seemed to get anywhere in their attempts to expose the corruption. Those who tried were usually led on a wild goose chase through the proper channels by the Gang until, out of frustration, they gave up.

## Enter Dr. Jacksont

Out of the first inspections, several standards were established. The Ryon/Blum report concluded by stating, "We recommend the immediate appointment of a General Superintendent, with a decent salary. This position, we think, calls for a man of ability, and men of this type are not easily secured without proper compensation for their services."

Dr. Jeffrey Allen Jackson, head of the insane department at Blockley, was called on to assume responsibility for the farms. A native of Georgia, Jackson had been a key figure in Philadelphia in the field of treatment for the insane. He graduated from Jefferson Medical College in 1906 and was a member of the editorial board of *Modern Hospital* magazine. Jackson had been an advocate for the colonies at Byberry from the start and seemed not to have an opinion either way of the Gang. Hoping for an administrative position at the Hospital for the Insane at Danville, Jackson accepted the offer of chief resident physician at Byberry in 1912, though it is doubtful that he actually lived at the colonies. The superintendent's home, the Stevens House, was not yet occupied and needed much work.

Jackson visited the colonies on a regular basis, but for all his wonderful abilities and contributions to the field, he was probably more of a figurehead put in place to satisfy the council's recommendation. While still the acting chief physician for the insane department at Blockley, Jackson's abilities were stretched thin. He did, however, put in place a system at Byberry that got it working more like an institution and less like a hobo camp. A temporary power plant was erected and began providing heat and electricity to most of the colony houses. Work began on the sewage treatment plant, and lines connecting it to the colony houses were laid.

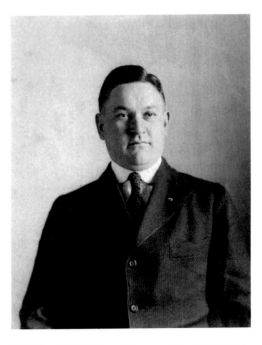

Dr. Jeffrey Allen Jackson, first superintendent, 1913. *Pennsylvania State Archives, RG-23.*

Jackson established new departments within the colonies and regrouped patients accordingly. He also was able to get a number of paid attendants hired. Jackson can certainly be credited with putting forth his best efforts to transform the colonies into a real institution.

Dr. Jackson enforced a suggestion made by the Ryon/Blum report for a records system, as none existed. For a short time thereafter, a sloppy but in-place system of keeping patient records was practiced. Jackson's efforts were beginning to meet with resistance from the Gang, whose own system of skimming Byberry's budget was also finding its place. The more records Jackson kept, the harder it was to manipulate the hospital. As the records system began to grow, however, the Gang simply stopped providing funds to support the position of record keeper. This just put more of a burden on Jackson and the chief physician, who ended up managing the records themselves. As Byberry's first superintendent, Jackson did not have much hands-on experience there. His "expertise" was displayed in a 1915 *Evening Public Ledger* article in which he declared that insanity was caused by alcohol use and blamed alcohol for half of Byberry's cases, perhaps as an excuse to push for transfers. Although he was a devoted doctor, his primary concern regarding the patients at the farms was the supervision of food, clothing and shelter, and he felt his talents were being wasted. Jackson was beginning to loathe the position.

## POWER SHIFT

The first two decades of the twentieth century was a time of transition in Philadelphia. The Gang's hold on city hall had lasted almost forty years, and cracks were beginning to show. The Gang's loyalty to its constituents was not subtle, and the working-class citizens of the city were tired of it. Its rival Republican faction, the Vare/McNichol/Penrose combo, had been pushing for power since Isreal Durham's banishment from the city. The more gangster-like trio knew how to appeal to the people. They understood the general attitude toward the Gang's aged methods of operation. They also knew how to keep the utility companies happy, without which the money flowing so freely in Philadelphia would disappear. The quickly rising Pennsylvania Railroad Company's executives would see to it that whoever ran city hall would appease their need for contracts. This faction would become known as "the Machine."

The three leading parties of the Machine were the vivacious Vare brothers of South Philadelphia, the polite and conservative yet notoriously crooked Senator Boise Penrose and Gang contractor turned ward boss James P. McNichol. William Vare, sometimes called "Baby Bill" but commonly known as "Boss Vare," was once a contractor of the Gang and had risen in status in the city. The Vares were renowned for swindling city hall out of millions, and their muscle-bound attitude toward their opponents was vicious. Coming from a long line of Philadelphia shipbuilders, Boise Penrose was already wealthy and did not necessarily use graft to line his own pockets. He was, however, extremely loyal to the utility and transportation companies that, as most knew, were the real government in Philadelphia. Penrose was the unchallenged boss of the city after Durham's death and was the de facto Machine leader, despite the Vares' attempts to unseat him.

The Gang was more representative of Victorian-era politics—ward bosses and rival neighborhoods, vote-buying and gift giving—and was much less subtle than the Machine. Over the next decade and a half, the Gang and the Machine went round and round on issues, in and out of the reformer role, with both carefully avoiding exposing their own corrupt agendas. Neither faction was necessarily honest, and they both had wealthy constituents to appease. The difference was merely policy. The Gang's old-school way of gathering votes and doing favors was also practiced by the Vare Machine, though in a gentler manner. Eventually, the Machine would force the Gang out of city hall.

Meanwhile, City Architect Philip H. Johnson had not received much flak from Gang-controlled city hall. He had held onto the connections he acquired as a member of the Gang. But as powers shifted, so did allegiances. Johnson stayed "in the money" by merging with the Machine. His position—along with his salary—rose into the official architect of the Department of Public Health. As DPH architect, Johnson received contracts for nearly every municipal hospital in southeastern Pennsylvania. During his illustrious career, he is credited with designing additions to Blockley and later the Philadelphia General Hospital (PGH), the Hospital for Contagious Diseases at Second and Luzerne, the City Hall Annex (now Courtyard hotel), the City Morgue, the Philadelphia Convention Center (now demolished), the Eastern Pennsylvania Institution for Feeble Minded and Epileptic (Pennhurst State School), the Pennsylvania Homeopathic Hospital (Allentown State Hospital) and many others.

## NEFF'S VISION

Director Neff, not wanting to recreate Blockley, was specific in his criterion for the new hospital. With a group of buildings, rather than a single building, more could be added as needed to accommodate overcrowding. Still planning to build on the Brown tract in Torresdale, Neff had a grand vision for the new hospital. After a survey was taken of the land, it was realized that the acreage was far too small for what the DPHC had planned. Not wanting to waste the department's newly approved $3 million appropriation on an inferior project, Neff suggested that "such buildings for the insane as may be constructed on the Byberry farms shall be of temporary character only, so that the tract may be devoted to other purposes without great financial loss when the State assumes care of the insane." He foresaw Byberry's predicament, having battled Blockley's numbers, and assumed from the beginning that State control was inevitable.

In a letter to Johnson, printed in the *Evening Public Ledger*, Neff's concerns to the architect were as follows:

*It is impossible to determine with accuracy the number of feeble minded to be cared for by the city of Philadelphia and their grouping. I desire you to figure, however, on the following estimate:*

*One cottage to accommodate 25 male idiots, one cottage to accommodate 25 female idiots, one cottage to accommodate 96 high grade imbeciles under 20 years, one cottage to accommodate 96 high grade imbeciles over 20 years, one cottage to accommodate 96 middle grade imbeciles over 20 years, one cottage to accommodate 48 middle grade imbeciles under 20 years, making a total of 368 beds. I estimate from the appropriation that we will be able to accommodate at least 400. Buildings needed will be Laundry, Power House, Administration building, Infirmary or hospital to contain forty beds, Stable, Industrial building, Amusement Hall, Dining Rooms, Kitchen and Store House. Cottages for feeble minded will be grouped around a common centre, in all probability a semi-circle, which buildings are to be placed 150 feet apart. I have spent considerable time on the grounds in laying out the various buildings, but the plan I had schemed was entirely frustrated after studying the survey that you brought to me yesterday, owing to the fact that Torresdale avenue is to cut through the middle and most important part of our property, and an entire rearrangement of grouping must be made. I had desired the administration building and the amusement hall in front of the woods facing the Bristol pike, with its beautiful approach through the avenue of handsome trees.*

## SURVEY SAYS: BYBERRY

When the Committee of One Hundred and the City Surveyors decided in 1912 to erect the new buildings at Byberry, the farmhouses were still being used to house patients, and more room was desperately needed. The department's plan was already in place. Moving away from the "Kirkbride" style of a single hospital building and deciding on a cottage plan, or a group of buildings, the city was clearly thinking progressively to avoid another Blockley situation. By erecting smaller, inexpensive buildings, rather than one large expensive structure, the city could easily add more as needed to maintain control of overcrowding. The 875 acres at Byberry that the City now owned could accommodate the need for space.

But before anything could be started, the friction of the Gang was pushing its way into the picture. In a second attempt to shake Johnson free from its dealings, on October 15, 1912, the Board of Charities approved a contract with Mark P. Wells to design two buildings to house three hundred male patients at Byberry. Upon hearing of this, Johnson sued the city for breach of contract, claiming his contract gave him sole responsibility of the design and construction of the buildings at Byberry. After a melody of praise and polishing by council, Johnson's contract held up. The Wells contract was thrown away, and Johnson received the rights for every building to be built at the hospital. This would only be the first of several times Johnson would be at battle in the courts over his precious contract.

The board had approved plans for three dormitory buildings in December 1908. The work began in January 1910 but was not completed for almost four years. These dormitories, the first buildings constructed by the city for its new hospital, were Buildings A and C in the East Group and Cottage I (C-9) in the West Group. The central sewage plant was built along the Poquessing Creek on the Keigler tract. On the East Group, the power plant and kitchen building was completed in 1914. The operation of the plant became difficult, however, as the supply of coal from the city's barges on the Delaware River had to be trucked in from the House of Correction property several times a day.

Most mental institutions in the early twentieth century contained patient cemeteries on their grounds. Peculiarly, Byberry did not. As part of Philadelphia County, Byberry's dead would have been collected by the county coroner's office. If not claimed by family after thirty-six hours, the body would be handed over to the State Anatomical Board for dissection purposes. Many thought this time frame too short and cried out against

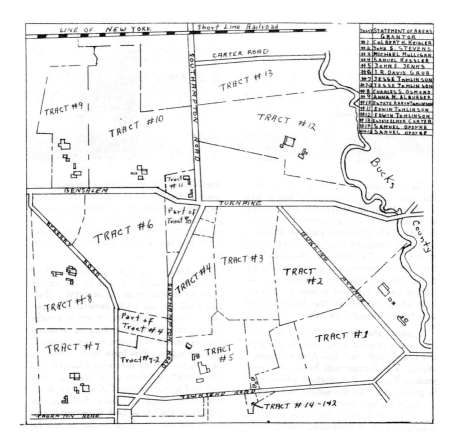

Map showing land purchases. *Author's collection.*

the "thirty-six hour law." County Coroner William R. Knight was one such person. He came up in the ranks as part of the post–Durham Gang and not without his share of accusations of jury tampering. But Knight proved an honest man—ultimately, too honest. The Gang had a hard time controlling him as he pressed for humanitarian causes, in some cases, at a cost to the city.

The laborers that built Byberry were mostly immigrants. They were bussed to the worksite from city hall every morning and paid thirty-five cents per hour. Johnson's contract gave him control of nearly every aspect of his projects, including the supervision of construction. Johnson rarely visited the Byberry worksite, however. He hired fellow Machine men to inspect the property in his place. While he hired cheap labor and used inferior materials, he charged the city top dollar and pocketed the difference. Ignorance and irresponsibility were already settling in at Byberry.

Chapter 3

# BUILDING BEDLAM

## *The Crooked Construction Process*

### JOHNSON'S "PERFECT PLAN"

Despite his discreet dealings and notoriety, Johnson produced designs that were undeniably interesting. They provide a stylized, almost caricatured look at one instance of early-twentieth century technology being applied to the field of public mental healthcare. His overuse of the Colonial Revival style of architecture applied to groups of cheerful, homey cottages and the simple engineering of their placement providing for courtyards with natural boundaries seems almost futuristic, yet historic. The clever use of connecting hallways and underground passages seemed ingenious, and the almost over-ornamentation of these designs appeared on paper to be almost perfect. The functionality of the campuses spoke for itself. An aerial view would provide just about everything one would need to get a good idea of the institution's operational features.

The Eastern Pennsylvania Hospital for Feeble-Minded and Epileptics (Pennhurst State School) in Spring City, Pennsylvania, was another institution that was created as a result of the Bullitt Bill. It, too, was designed by Johnson during the term of director Krusen, and it, too, featured Colonial Revival–style buildings connected by underground passageways. In fact, his design for Byberry differed only slightly from that of Pennhurst. Johnson's designs for hospital campuses, despite their individual specific needs, all provided exactly the same feature: basic housing. Buildings in his cottage plans were named alphabetically in letters, a Johnson trademark. It is important to

note that the origins of a well-envisioned municipal healthcare system, in accordance with the Bullitt Charter, provided Philadelphia with two separate mental facilities at Byberry, not one.

The concept called for patterns of buildings, each designed for a certain classification of mental illness. Before advancements in medical science pushed this plan out of the realm of feasibility, Philadelphia succeeded in building two of these colonies. Under the rationalE of early twentieth-century medicine, the city built a colony for patients deemed "insane" and another for those labeled "feeble-minded." The cartoonish cottages proved immediately inadequate. Their nineteenth-century design was great for a nineteenth-century population, but Philadelphia's numbers spiked more in the decade after the First World War than at any other period in its history. In the shifting gears of a fast-growing city, the new old-fashioned hospital seemed like a joke. Its cottages were drenched by a deluge of unprecedented patient numbers and were naturally incapable of absorbing them all. But few seemed to realize that no institution existing in the United States—public or private—could have held up under such an impact.

The city's third attempt to break Johnson's perpetual contract came in 1914. Congressman J. Hampton Moore, frustrated by the antiquated "new" hospital his city was forced to cope with, hired a team of architects to probe into Johnson's career and architectural training. They turned up a muddled past. No proof could be found that Johnson had any real architectural training at all. Moore appointed John P.B. Sinkler as city architect and instructed him to work on plans for new buildings at Byberry. Meanwhile, his close study of the contract found that Johnson had no legal claim to the title of city architect itself. It stated that Johnson was to receive all work from city municipal departments that had existed at the time of the contract's inception (1903). This meant that when the DPHC broke down into two departments, Johnson's contract only entitled him to the work of one. The courts agreed, and Sinkler was placed into Johnson's previous position. Johnson had no trouble opening his own architectural firm however, backed by Machine connections. The contract was still valid when it came to Johnson's 5 percent commission, and he was sure to collect it.

## The East Group

Situated near the existing 1908 tubercular pavilion, on the east side of the Lincoln Highway (now Roosevelt Boulevard), the East Group (later known as the "E" buildings for "East") was the first of three projects by Philip H. Johnson for the DPHC at Byberry. The buildings were designed to house male patients. In the decade or so preceding any actual construction, the city's hyped-up new hospital had been referred to simply as the "Philadelphia Hospital for the Insane," as the new buildings had not yet received an official title. By the 1920s, they would become known as the "Philadelphia Hospital for Mental Diseases" (PHMD). The East Group, when completed, would consist of eleven buildings (including two crude workshops). The first four buildings to be constructed were buildings A, C, D and F, the four corner buildings, which were later labeled E-2, E-6, E-3, and E-7, respectively (see map on page 5). At the same time, the east power plant was slowly coming together. It was furnished with boilers and operational by 1918. The administration building for the East Group was ready for use by 1920. Two more dormitories would be added by 1924.

The buildings featured two-story central hubs with one-story wings on each side. The central hubs contained main lobbies with nurses' stations and bathrooms, and the wings contained the beds. They were not designed with day rooms, activity rooms or any other basic comforts of a proper institution, perhaps because at the time of their design, the agricultural therapy concept

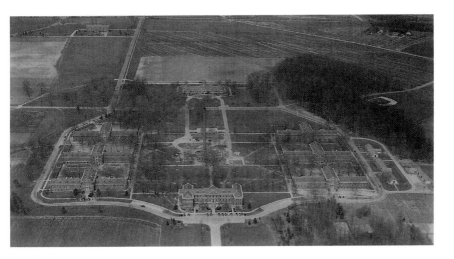

The East Group, 1950. *Author's collection.*

was still the driving idea. They would be situated in an H-shaped pattern with the dormitories placed in two rows and the power plant in the center to provide heat to the campus via pipes in underground passages capped on ground level by sidewalks. Running parallel to the steam tunnels were traffic tunnels used by patients to travel between buildings.

The buildings were in the Colonial Revival style and were constructed of brick with granite capstones and lentils. The roofs were slate and the frames and floors wooden. The power plant for the East Group was connected to the kitchen and dining hall. The most ornate building in the East Group was the administration building. This was a two-story building with a grand front façade and sculptured cornerstone. It contained the offices and clerical department. The layout and idea of the campus was forward-thinking and, at the same time, sinister. The idea of patients traveling between buildings via underground tunnels to prevent the chance of escape was a show of the city's attitude toward mental diseases and the stigma that existed about people with them. From the outside, the buildings looked residential and unthreatening, like a small neighborhood or a colonial town. The only other structures visible from the new buildings were the original farmhouses, many of which still housed patients.

## THE WEST GROUP

The West Group, situated near the northwest corner of Southampton Road and the Lincoln Highway, opposite the East Group, was designed to house the growing population of women who were building up on Blockley's wards. These buildings, like the others, were originally designated in letters. In later years, however, as more buildings were added and the hospital's land borders changed, they would be re-zoned as the C (central) group and labeled by number. They were more attractive but also more expensive. This new campus featured concrete floors and aboveground connecting corridors rather than dark tunnels for patient travel. The corridors were tall and well lit through large decorative windows. The pipes carrying hot water from the west power plant ran below the connecting hallways, and the hallways themselves formed the boundaries of well-groomed patient courtyards. The buildings were two stories high with open porches on each end of the second floor. They included dumbwaiters and laundry chutes, visiting areas and modern nurses' stations, as well as patient activity areas in the basements.

Johnson continued the same layout as the East Group. The dormitories were built in two rows for easy expansion and the addition of more structures. Between the rows of dormitories was the refectory, laundry, infirmary and administrative buildings. The power plant for the West Group, however, was located two thousand feet from the campus, across Southampton road. Unlike the east power plant, the new power plant was to receive its coal supply via rail car, and therefore a connection to the Reading Railroad's line (later the New York Short Line) about a half mile from the hospital was necessary. After months of disputes between the city and the Reading over who should pay for this stretch, the city finally footed the bill.

The first building erected on the West Group, as previously mentioned, was building I (C-9) in 1910. Next up was the laundry building (C-13) in 1911, followed by the two tubercular buildings, B and C (C-6 and C-12), and building H (C-3) in 1912 and the refectory in 1913. The board did not approve more funding until after the war ended. Then, in 1918, the four buildings at the outer corners of the West Group—buildings D, E, J and K (C-1, 7, 5 and 11)—were constructed. These four buildings were cottages

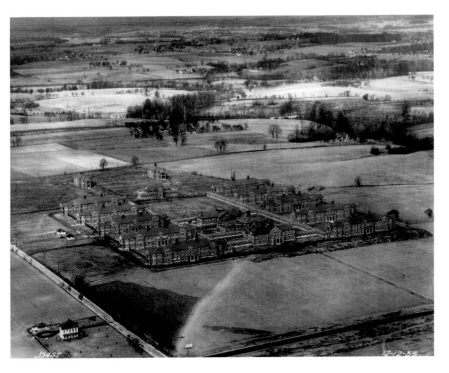

The West Group, 1935. *PhillyHistory.org.*

for patients designated "High Grade Feeble-Minded." The administration building was completed by 1923, and in 1924, buildings F, G, L and M (C-2, 4, 8 and 10), the cottages for "Low Grade Feeble-Minded," were added. By 1925, the connecting hallways were in place, and the West Group, except for the infirmary, was complete (see map on page 5).

But before the East Group was completed, Byberry's first public murder hit headlines. In 1916, a patient named David Friedman easily found his way into the medicine closet in building D and, in amusement, mixed a bottle of formaldehyde into the building's supply of medicine. This resulted in eleven patients almost poisoned to death and taken to the infirmary, with one dead. Friedman was placed back onto his ward with no reprimanding.

After only a month, another situation arose. Five buildings on the West Group were completed but remained empty due to lack of heat. The contracts for the power plant had been awarded to Mitchell Bros. Company for construction. The work was about halfway complete when a political rift forced it to stop. Director of Public Charities Dr. Harte called for assistant director Alexander M. Wilson's resignation, claiming that he was too involved with the Gang. After months of debate, Wilson decided not to resign, and Harte did instead. His replacement sat on the appropriation money for the plant, and it continued to sit, half complete. When Mitchell Bros. was finally contacted again to complete the plant, the company tried to rescind its bid, claiming it was $100,000 too low. More legal bickering followed, and two years had gone by since the original bid was placed.

By December, when the bid was again worked out and the extra $100,000 agreed to, enough time had passed to allow costs to go up. Mitchell Bros. once again held up the contract. After an additional $50,000 was given, the work finally proceeded and the west power plant was completed by November 1916. Under pressure to relieve Blockley, Krusen began the transfer of its patients to the new buildings of West Group. "With the heat and power plant completed," said Krusen, "we can go ahead with actual relief of conditions at the old almshouse, and this is my purpose. Immediately upon completion of the plant, I will begin to move inmates from Blockley to Byberry. I shall send about six hundred there at once."

Krusen was not exaggerating. At the end of November, he moved three hundred patients and then another three hundred in early December. The new power plant was completed, and all seemed to be going as planned. But immediately after the patients arrived, it was discovered

Female Refectory, West Group. *Pennsylvania State Archives, RG-23.*

that the pipes connecting the buildings to the new plant had not been laid properly. The plumbing contract was held by William McCoach Jr., son of a Machine councilman and a Vare cohort. Having been "juiced in" by his Machine connections, most in city council were afraid to interfere with him. Meanwhile, the fate of six hundred female patients hung in the balance. An article in the *Philadelphia Inquirer* told of the rush to get the plant working before the winter in fear of the patients freezing to death in their new buildings. It told of the shoddy work done by the "Johnson clan" in the laying of the pipes, a charge that was actually unjust. It was discovered that some pipes were not even connected. McCoach had ordered his men to stop working at Byberry until he received a commission that he claimed was never paid. But McCoach was willing to use the freezing patients as collateral for his payment. He was sure he could get the city to pay at the threat of their safety. The city, however, fought McCoach, drawing out even further the patients' discomfort. Eventually, the city caved and paid a second time to have the pipes laid properly. It was rumored that even donated funds were required to complete the work before the end of the month.

## Shell Shocked: The Military Contract

The outbreak of World War I called many of the able-bodied farmers in the Byberry area off to service. It also put a halt on the construction of buildings and slowed the farm's fiscal output to a crawl. In 1917, DPHC director Wilmer Krusen figured out a way to keep the farm's production alive by setting up a youth training camp for "soldier-farmers." This called for a military-style camp, endorsed by the War Department, with three new temporary dormitory buildings and a kitchen/dining room building. These wooden buildings were able to be built and occupied quickly, and a strict daily routine was put in place.

These cottages were located on a portion of the Aaron Tomlinson Tract, next to the Byberry Creek, at the current site of Hornig Road. The existing barn and several dwelling houses were utilized. The cottages housed forty boys from nearby schools who ranged in age from sixteen to eighteen. The boys were given uniforms, and they drilled and marched daily. They did farm work, harvesting the city's crop for shipment, and learned new skills in the process. A new tractor was purchased for the camp, and the boys learned how to use it. Captain John McAllister, who was also the director of the Bureau of Hospitals, was placed in charge of the camp, and he reported that nearly half of the boys enlisted to full duty and were sent to France after completing training.

Though a short-lived idea, Krusen's camp contributed to the war effort and was well received by the public. Wealthy Byberry landowner Thomas Shallcross was so impressed by the boys' camp that he contributed a large sum of money to the city for the construction of the Shallcross Farm School. Still standing near the present-day intersection of Woodhaven and Knights Roads, the Shallcross Farm School became another of Philip Johnson's projects, most likely due to the involvement of his friend Krusen. Although the first, the boys' camp was not the last of Byberry's connections to the First World War.

With the success of the boys' camp shedding light on Byberry, Krusen appealed to the United States Army Board to consider it a site for a war hospital. Landing a contract with the army would mean substantial funding for the city and the hospital. With the Great War coming to a close in 1918 and the state looking for places to send its returning servicemen for treatment, Surgeon General W.C. Gorgas agreed to Krusen's offer. The first five buildings of the East Group—or buildings for "insane males"—were leased to the military. The recipient of the government funds was presumably

the city, but some infighting with the DPHC may have meant both parties received portions.

Four dormitory buildings and a central kitchen building were nearing completion in July 1918 when an inspector from the War Department came to visit the site. He found the buildings to be ideal for the military's purposes, and Gorgas approved the contract. The four buildings could hold one thousand wounded soldiers, and the buildings themselves encompassed two hundred acres of landscaped lawns and walks. Having had to fight politically with other state factions and hospitals over the contract, the DPHC was a bit weary, and now it would have to push to meet the deadline set by the military of January 1, 1919. Before the deadline came, however, the surgeon general's office was questioning Byberry's location, calling it "inaccessible."

Delays in the buildings' construction were not helping the war department's decision. Hold-ups over McCoach's contract for plumbing work dragged the process along. Machine Mayor Smith backed McCoach, and as the city battled with itself, the military looked on despairingly. But by March 1919, Gorgas had lost his patience, and the military canceled its contract with the City of Brotherly Love. Byberry's beginnings would have been far nobler—and perhaps its whole history would be different—if the military contract had been successful. Historically speaking however, the military's decision was definitely for the best.

The aftereffects of the war did not spare Byberry, however. Waves of servicemen returned with post-traumatic stress disorder (PTSD) or "shell-shock." The times were changing fast, and Byberry was forced to carry the increasing load. Throughout 1919 and 1920, wounded servicemen found themselves at Byberry, among hundreds of insane patients from Blockley. The city's underpaid staff was totally inexperienced when it came to war-broken soldiers. Hiring attendants who were willing to live on the grounds, deal with the decrepit conditions and maintain control of the rising number of patients—all for a minuscule wage—was almost impossible. According to the *Inquirer*, in a desperate attempt to hire attendants, a sign was put up along the Lincoln Highway, retrieving a "group of drunks," Byberry's chief physician chirped. The totally unprepared new hires at the farms found themselves in control of hundreds of patients, and many found the temptation to steal from the helpless patients too strong to resist.

In 1919, two male attendants were arrested for murdering a male patient. Another staff member testified that one attendant held the patient down while the other "choked him till his eyes popped out." It was learned that both men had just returned from the war themselves and were probably suffering

from post-traumatic stress disorder. Charges were dropped, and both men were re-hired with raises in salary and position. This story is probably what gave the public its first—and long-lasting—negative impression of Byberry. From this point on, Byberry seemed to remain stigmatized, and one horror story after another was released in the newspapers. Fearing another Blockley situation, the city pressed for construction to continue, and amid more scandal, it slowly did.

Fortunately, right from the beginning there were also good people who battled Byberry's curse. In 1920, the likable reformist J. Hampton Moore, riding on the shoulders of a powerful new reform party backed by wealthy, influential figures like John Wanamaker, was elected mayor. With him, other reformers entered positions in city hall, and Byberry was a priority on their list. Director of the Department of Public Welfare Barclay Harding Warburton did not waste any time in presenting before the council accusations of extortion at Byberry. Warburton claimed that wages paid to the workers totaled $12,000 in 1919. But of the $12,000, only $8,000 was found to be properly dispensed. The rest, he claimed, was used to line the pockets of the chief farmer and resident physician, who were probably being forced to kick some up to figures unknown. He could not, however, prove any of these charges. Another of Warburton's concerns was that the patients were being "taken to the polls in blocks of three hundred" and told how to cast their votes. The idea of getting someone elected through the control of votes by insane patients who may or may not understand their own actions is certainly a new high in lows for the City of Philadelphia.

J. Hampton Moore had taken an interest in reforming Blockley when he first learned of its situation as a reporter for the *Evening Public Ledger* in the 1890s. As city treasurer from 1900 to 1904, he was well aware of the Gang's agenda when contracts for buildings at Byberry began to circulate. As a congressman from 1906 to 1920, he tried several times to expose the Machine's abuses of the city's contracts. As mayor from 1920 to 1924, he succeeded in temporarily reforming the sloppy scene at Byberry, continued the construction of Johnson's plans and lit the way for the hospital's future.

# THE PHILADELPHIA HOSPITAL FOR MENTAL DISEASES

## *The City Years*

### FROM "INSANE" TO "MENTALLY SICK"

Not yet officially opened, Byberry was already surpassing Blockley's numbers. The patient population in 1920 was approximately one thousand male and seven hundred female patients. There were seven buildings completed on the east side and ten on the west side. The changing times in America due to the victory in France and the booming economy brought on a huge building boom in Philadelphia. Perhaps for the first time, the construction of buildings at Byberry seemed a priority to the city. As the buildings in the East Group were nearing completion, Chief Physician Jeffrey A. Jackson was finally offered the position he originally wanted at Danville State Hospital, which offered better wages and board for an experienced doctor such as Jackson. His resignation was given, happily, and Jackson practically fled from Byberry, leaving it once again with no experienced doctor to see to its day-to-day operations. Jackson remained the superintendent of Danville State Hospital until he died in 1938 at fifty-four years of age. He is still regarded as a pioneer in the field of neurology.

After a few months, the position was filled by Dr. Samuel W. Hamilton, in his first administrative position. During Hamilton's time in charge, some changes for the better were made. Realizing that his requests for more funding and supplies were falling on deaf ears, Hamilton did what he could by attempting to establish activities and hydrotherapy for his patients. Hamilton saw the completion of the east campus come to fruition, and he expanded

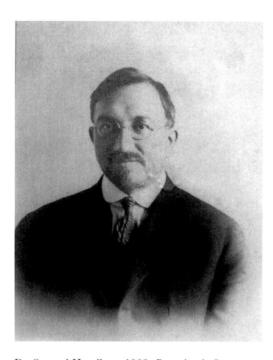

Dr. Samuel Hamilton, 1923. *Pennsylvania State Archives, RG-23.*

farm work for male patients. The Occupational Therapy department began in 1920 under the guidance of Dr. Frank P. Lane. It was in control of all of the patient-produced goods, such as brooms, clothes, mattresses and agricultural products. The patients built most of the goods they used until the mid-1920s, when city council began appropriating more funds for this purpose.

In 1922, Machine leader Boise Penrose died, giving William Vare his long-awaited turn at the helm. Vare was one of Philadelphia's most notorious gangster-politicians. His vote-counting abilities were some of the best. His oligarchy usually controlled every ward in South Philadelphia. However, Republican governor Gifford Pinchot, who managed to climb into the governorship amid all the infighting between rival Republican factions, became "Baby" Bill Vare's archenemy. In 1926, shortly after taking office, Pinchot refused to even consider allowing an election in which Vare was running, due to his vote-buying legacy. But until his death in 1934, Vare ran a powerful Machine. The new administration, by gaining control of city hall, inherited the "Byberry Bank." The Vare Machine had been taking generously from Byberry's budget, as previous administrations had done, having had one of its own as city controller for more than three decades.

As a result of the seemingly increasing greed of the new administration, Byberry's budget actually increased. The Machine had no difficulty acquiring funds for Byberry, but the hospital saw less and less of it. This is probably what caused Samuel W. Hamilton to resign as chief physician rather abruptly in 1923. Hamilton ended his career as the superintendent of the Essex County Overbrook Hospital in Cedar Grove, New Jersey, and died in 1951. Hamilton's replacement was Dr. Everett Sperry Barr. Barr

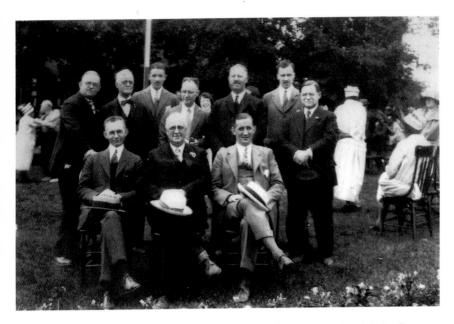

Byberry picnic, probably at official opening celebration, 1926. *Seated left to right:* Dr. Everett S. Barr, Dr. Wilmer Krusen, Dr. J.C. Doane. Standing at left is Edward A. McNally. *Pennsylvania State Archives, RG-23.*

entered the position, as did his predecessors, with the attitude of change and progress. His efforts at state intervention were easily blocked, as Hamilton's had been. But Barr would remain through some considerably better years. He was probably the first superintendent to occupy the Stevens House.

In 1925, Barr, on a tour of the West Group, explained to a *Trenton Sunday Times* reporter, "These patients were insane before, now they are merely mentally sick." The female patients were busy doing activities in the workshops on the second floor of the refectory. There they knitted sweaters and scarves, producing over five hundred items a month. The west campus was almost completed, and the cost was already $6 million and predicted to reach over $10 million. The *Trenton Sunday Times* exclaimed, "Great work being done for Mental Cripples of Philadelphia at City's fine hospital on Lincoln Highway." The Roaring Twenties seemed to lend some grace and style to Byberry's final design and planning curriculum. Its inner gears turned faster, and its system solidified. The next five years would be the best period the hospital had yet seen.

# THE SOUTH GROUP (PIFM)

The South Group, located on approximately two acres of the Aaron Tomlinson tract, began as a separate institution altogether. "Feeble-minded" was an early twentieth century term for children with mental diseases. It has been replaced, for the most part, with the term "developmentally disabled." The Bullitt Bill required the erection of buildings specifically for housing this class as a separately funded and operated hospital. Under the title of the "Philadelphia Institution for Feeble-Minded" (PIFM), six cottages and a central dining room were completed in March and received their first 123 children from Blockley in April 1925. The cottages were one-story structures with basements. A kitchen and dining hall was also built in the center, following the layout almost exactly from the East Group. The cottages were L-shaped, however, with wards in each wing and a dayroom in the center. Each contained a nurses' station, one shower, one bathroom and a partitioned room in each dayroom lined by paned glass for isolating children with contagious diseases. They each had an official capacity for 60 children, holding a total of 360, although they would hold almost twice that at their peak. Dr. Barr reported in February 1925 that the total cost of the new group was approximately $450,000. The optimistic superintendent spoke whimsically of the new buildings:

> *The whole group will be operated as a unit distinct from Byberry Hospital, but with the cooperation of the main staff. Each cottage is worth $60,000 dollars. This cost would be much higher except for the fact that all our heating, lighting, and sewage is handled by the central plant which takes care of the entire hospital. A great many of these children can be trained to become useful and self-supporting. That is why we are putting them in these congenial surroundings in smaller groups, where they can be given better and more individual care. Our plans go so far as to have each cottage slightly different from the rest, to conform to the needs of certain types of these patients.*

The hospital's official report for 1925, its first, was uplifting. It boasted that the new group also provided a school that offered grade instruction to the children and lists two teachers on its payroll: Caroline Gumm and Beatrice Rubin. It showed an institution that was well staffed, well managed and eager to help its patients. With an impressive workforce, including a night supervisor, five nurses, sixteen attendants, six "ward maids," two waitresses,

The Stevens House on Burling Avenue acted as the superintendent's home, 1935.
*Pennsylvania State Archives, RG-23.*

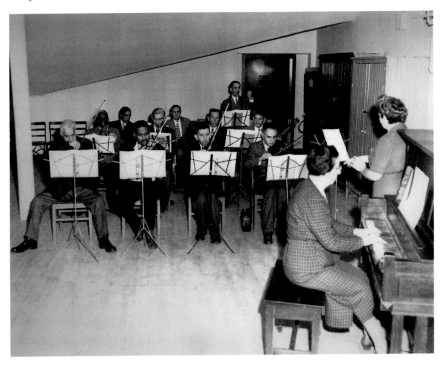

Male patients at band practice in the West Refectory, circa 1935. *Pennsylvania State Archives, RG-23.*

two cooks, two maintenance men and a dishwasher, the city spared no expense in its attempt to expand the "farms" into a fully-functioning facility. Physician-in-Charge Stephen M. Smith tells of the new hospital:

> *There are classes for corrective work in speech defect. The academic work comprises reading, spelling, penmanship, fundamental processes in arithmetic, and hygiene. The older boys receive training in woodworking and the older girls in clay modeling. The occupational classes give instruction in basketry, weaving, and domestic arts. The physical therapy classes are given training in corrective and educational gymnastics and folk dancing. All pupils are given training in music. Classes are held from 9 to 11 A.M. and from 1 to 4 P.M. Every child in the hospital of sufficient chronological age is given a trial in the schoolroom to see if he or she is teachable.*

For the first year of its existence at least, PIFM seemed like a very reasonable institution indeed. Its budget had not yet been tampered with or crippled by the Great Depression. However, it is truly difficult to picture Byberry as the idyllic, fairy-tale retreat the report made it seem.

## THE MONIES OF THE TWENTIES

The 1920s was one of the most prosperous decades for America. Building booms were underway in every major city, unemployment was low, wages were at a high and an all-around attitude of American pride was looming. The high caused by America's victory in the war, the manufacturing boom in Philadelphia and new technological advancements all helped to soften the spotlight on Byberry. Although the staff generally referred to the year 1925 as Byberry's "red letter year," it was officially opened by the city in 1926. But by that time, Byberry had been the focus of several investigations, and Dr. Barr was busy with the public relations aspect of the hospital. The last building for patients had been completed, and every building was filled to its designated capacity.

Ironically, the city planned its official opening for 1926, hoping to add it as a feature in the city's precarious Sesquicentennial Exhibition. It was soon taken off that list due to its continuing delays in construction caused by the Machine's graft. The opening, despite attempts at publicity, went off rather quietly. Dr. Barr gave tours to newspaper reporters as well as state and city

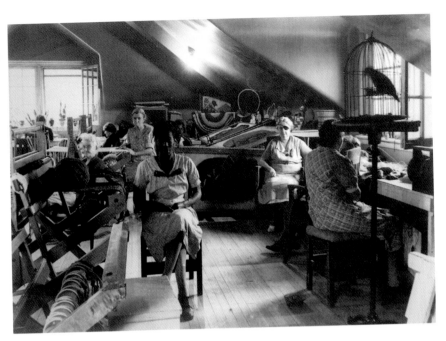

Female patients in clothing shop, circa 1933. *Pennsylvania State Archives, RG-23.*

officials in hopes that he could somehow alter Byberry's negative reputation. The opinions of visitors, however, was not what the city was expecting. Attention was called to a lack of housing for attendants, inadequate transportation to and from the hospital and a lack of properly trained staff to operate the new features of the buildings, such as hydrotherapy tubs and "humane" restraints. The city's hopeful attitude quickly subsided as it realized it still did not have a modern mental hospital. Johnson's plans were dusted off, and several new buildings were approved.

During the mayoral term of W. Freeland Kendrick, Philadelphians were not struggling. Businesses were thriving, and the biggest building boom in the city's history took place. Almost 35 percent of public buildings still existing in the city today were constructed during this period. The "wet" city was drowning in illegal alcohol, and the money was flowing heavily. However, only a dog's share managed to find its way to Byberry. Taking up the reigns of reform from J. Hampton Moore in 1924, Kendrick began with a good head start on the Byberry situation. He oversaw the completion of all three groups and clearly took the institution seriously. He attended the hospital's official opening in 1926, and made frequent inquests of its condition. The Sesquicentennial Exhibition was the priority of the administration and the

city's business leaders. Ironically, the city's overhyped and underfunded celebration of the 150th anniversary of the signing of the Declaration of Independence ended up a washout, literally: unusually frequent and drenching rains kept visitors away, not to mention the political civil war that took place during the planning of the exhibition. Infighting among the city's elite, official and private, spilled out onto the headlines long before the event took place, leading to further disinterest by the rest of the nation.

A big portion of the fighting was over where to build the gigantic fairgrounds that were planned. One location suggested was along the city's new Northeast Boulevard (Roosevelt Boulevard), near Pennypack Circle. This would showcase some of Johnson's work along the highway, such as the new Shriner's Hospital for Crippled Children. It would have also changed Byberry's course by forcing the city to fund more of Johnson's buildings and keep a closer eye on Byberry in light of its featured location. But the South Philly–bred Vare Machine eventually won out, and the city chose to hold the fair on swampland south of Oregon Avenue that it would have to pay Vare contractors to fill in prior to any construction. The "Sesqui" was a flop, and the city lost face as well as money.

After the storm the exhibition brought to town finally blew away, the city approved a $1.2 million appropriation for new buildings at Byberry, and the finishing touches were put on. In 1928, the building for tubercular male patients was added to west end of the East Group. The one-story structure featured airy porches, wheelchair ramps and room for two hundred patients, although the hospital needed room for almost eight

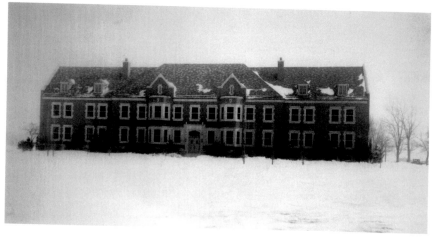

Doctor's Home, 1935. *Pennsylvania State Archives, RG-23.*

hundred. Again, a structure designed before the population boom that followed the war, the new building was antiquated, old-fashioned and inadequate for the hospital's needs.

The Doctors' Residence followed. Ornate, airy and roomy, it featured luxurious apartments for the doctors and physicians. The Male Attendants' Home, however, was spared much more expense. Attendants for the East Group lived in a condition similar to that of the patients they cared for: crammed together. Two stories in height and very unaccommodating, the attendants' home filled up fast. The two new buildings for male staff were located on the east side with the male population, but some attendants still lived in the Carver House, despite the construction of the new quarters.

## Mercury Rises

In 1928, Philadelphians elected a flashy, smooth-talking new mayor. Harry Arista Mackey began his career as a football player. He later became a coach and, through his public highlights, finally became a lawyer. Mackey was a Machine man and had gotten elected on the backs of the utility companies. As mayor during the stock market crash and the beginning of the Depression that followed, Mackey was surely dealt a tough hand. But his true strength was his magnificent showmanship. During his first two years in office, he managed to jump around the Byberry situation, but whether or not he had true knowledge of the conditions that were beginning to fester when he took office is not clear. He certainly spun the situation in a positive light when questioned about the hospital's problems. "I admit we have crowded conditions, but no insanitary conditions," he told reporters. "The patients get as much care as if they were millionaires."

Philadelphians liked Mackey. Public sentiment was usually on the mayor's side, and he played the role perfectly. "Hardly a week goes by that I do not visit the hospital," he claimed. "The patients will tell you that I am the only mayor who ever went out there and shook their hands and inquired about their health." For all his talk, however, Mackey proved little more than a showpiece for the Machine, incapable of softening the blow on the hospital's frail infrastructure.

Mackey, under the guidance from his Machine puppeteers, was pressing for a way to replace Dr. Barr as superintendent and replace him with one of their own. Barr was not interested in the Machine's gifts, only in running his

hospital. He made the siphoning off of Byberry's budget very difficult for the Machine and thus presented an obstacle. While Mackey turned up the heat on Byberry, making inquests and inquiries, Barr remained confident that his administration would show no flaws. Director of the Department of Public Health Dr. A.A. Cairns had reasons of his own to oust Barr. Cairns came up with Krusen and Johnson and had loyal Gang connections.

After the city controller's report surfaced, Dr. Barr's "miscellaneous" fund was brought to light and used as the fatal weapon against him. The miscellaneous fund was made up of cash taken from patients upon their arrival. The fund was supposedly used to disperse money to patients at their request and for their care. However, the city controller's recent account of the hospital's books showed that the fund was being used as a personal bank for a few of the top staff. Barr himself was brought into the spotlight, and he was intensely interrogated. The fund, Barr claimed, was only used for patient care and supplies. But the controller claimed that the account was thousands of dollars short.

Although he was cleared of any knowledge of the fund's misuse, the heat ultimately led Barr to resign, along with assistant superintendent Stephen L. Smith. Barr transferred to the Chester County Hospital at West Chester, where he received a marked increase in salary. Both men cited tight constraint and lack of cooperation from city hall as their reasons for transferring. Smith addressed the decision, stating, "Both Dr. Barr and I wanted to make Byberry the finest hospital of its kind in the country, and if they had only let us alone, I think we would have done it." Smith continued, "I'm a little heartbroken about it, I suppose. But when it comes to the point where a man in charge of an institution like this cannot engage an assistant of any kind without getting a ward leader to vouch for him, it's pretty bad."

Smith was aggravated by the Machine's hold on the hospital he so desperately wanted to mold into a top-notch institution. Smith also cast some of the blame on Dr. Cairns for not having a stronger grasp of the situation. He stated that Cairns honored political favors, although probably forced to do so. Giving some examples of political favoritism, Smith referenced at least seven instances he had documented of staff connected to the Machine.

In 1927, according to Smith, an employee was discharged for drunkenness and failure to report to work. He was re-hired a year later and, after only months, was discharged again for improper conduct to hospital guests and, again, drunkenness. Hired back yet again, the employee was finally discharged a third and final time for being intoxicated on the job. "Many of the clerical employees are out-and-out political appointees, sent here

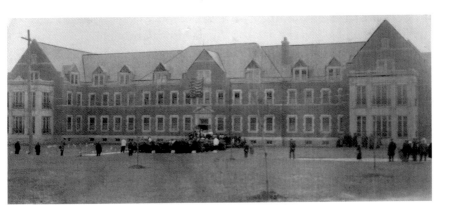

Dedication of Nurses' Home, 1929. *Temple University Urban Archives.*

with absolutely no regard for their ability to do the work they are intended to do." Smith said. "One of the younger physicians, who was without his license, was ordered to remain. His brother-in-law was a member of the state legislature. He was not only permitted to stay, but he was given the maximum salary increase as well. In this particular case, this man's wife was kept on the payroll as a laboratory technician, yet she is here very little, perhaps ten or fifteen minutes a day."

In March 1929, the new Nurses' Home was dedicated on Southampton Road, facing the West Group. Almost identical to the male attendants' quarters, this building graciously housed the hospital's nurses, due to the fact that there were but a small number on staff. There was no building for female attendants. They lived on designated wards in the patient dormitories on the West Group. This became a problem as more attendants were hired, forcing the patients to live in attics, basements and hallways. It also prevented attendants from ever having visitors or much of a home life at all, contributing to their sinking job performance. Once completed, the new staff buildings were already inadequate to the hospital's staff population. Additional buildings were already being asked for.

Still without a permanent administrator since Barr's resignation, public health director Cairns recommended Dr. James P. Sands for the superintendent position at a salary of $5,500 a year. Sands had been the clinical director at Friends Hospital. He was renown as a caring psychologist and was a personal friend of Cairns. It seemed the Machine had found its next figurehead. On November 18, 1929, his appointment was approved by Mackey and Cairns. Meanwhile, Mackey denied any political motives for Barr's resignation, but it seemed like a smokescreen. "I want to assure you

that the despoiling hands of politics will never enter the hospitals in the city," Mackey said. "No multi-millionaire could purchase more science or care than is being given at the Philadelphia Hospital at Byberry."

In 1929, Mackey made a bold request to the Finance Committee of City Council for $5 million for the erection of new buildings. He received only $650,000, enough to construct an additional residence for physicians, an addition to the nurses' home for female attendants and an enlargement of the sewer plant. It was still possible to request funding from the City, but the Wall Street crash would soon slow it to a drip. The fragile public was nearly recovered from the shocking stories coming out of Byberry when it shot to the front page again.

Three patients died under circumstances that the coroner called "mysterious." One was a twelve-year-old girl, Mary Matysik, who became tangled in her restraints and choked to death. The other two seemed less like "accidents," as classified by the hospital. One was twenty-three-year-old

The mattress shop on the East Group was one of the only forms of recreation for male patients, not to mention the hospital's only mattress supply, circa 1940. *Pennsylvania State Archives, RG-23.*

Anna Alter, who plunged from a roof. Dr. Cairns demanded a deeper probe and told investigators, "Press the investigation to its end regardless of whom it hurts." The lack of staff proved to be the reason for Matysik's death. The attendant in charge of her ward admitted tying Matysik "to prevent her from biting herself." The first investigation showed that a number of patients had been placed into attendant positions to fill the gap. Apparently only one paid employee was in charge of the children's group. The majority of the children's caregivers were patients themselves.

In January 1931, a case was brought before assistant director of public health George Knowles that he called "incredible—almost like fiction." Sixty-year-old Charles J. Lewis, of Baltimore, was found wandering the city in 1926 in a "dazed condition" by police and sent to Byberry. He had wandered from his home in 1924 and was pronounced dead. His identity only came to the attention of Dr. Cairns when he found a set of safety deposit box keys and bank account information for one Charles J. Lewis of Baltimore. Lewis's family was notified, and they were ecstatic. He was finally released to them, along with his property, in 1931. No hospital official was linked to a plot to withdraw Lewis's $3,724 upon learning of his deceased status…but it was an unmistakably Byberr-ian move.

As construction continued on the new staff buildings, Dr. Cairns tried to raise public awareness of the overcrowding by giving an interview with the *Evening Bulletin*. He spoke of firetrap buildings, lack of food and, perhaps for the first time, the ever-increasing overcrowding. Cairns gave some specific examples of the hazards of life at Byberry. "Hoseington House, where a number of old men are cared for, is a disgrace to the city," he said. "It is really nothing more than an old barn. It would go up like powder if a fire started there. It is not safe to use it another day, but we have no choice, because there is nowhere else to put the patients who occupy it."

Aside from dozens of instances of fire hazards, Cairns noted that the population of the hospital increased by about 350 patients a year and that the situation was getting dire. "It is difficult for persons not familiar with conditions at Byberry to realize just how bad they are," he said. "A casual examination would shock almost anyone because of the overcrowding. There are other effects of the overcrowding that are just as serious, although not quite so obvious. We are obliged to keep in the infirmary of the men's hospital idiot boys of fifteen and sixteen who have no business there at all."

The hospital's reputation was beginning to circulate, and as it got stronger, it repelled more would-be attendants from applying. Dr. Cairns took note of this early, and his prediction that soon it would be next to impossible to

Thomas Boyd (left), acting for Philip H. Johnson, gives Nurses' Home keys to Mayor Mackey in 1929. Dr. A.A. Cairns looks on at right. *Temple University Urban Archives.*

find anyone willing to fill the needed positions was more true than he knew. "With the conditions as they are now, when there is no provision for the medical staff and doctors are forced to sleep with patients, it is impossible for us to get physicians. At the present moment there are seven vacancies for physicians at the hospital. Although we have appropriations to pay these salaries, we cannot get men to take the posts because there are no suitable quarters for them."

## MACKEY'S MASSES

On March 31, 1931, Cairns's meeting took place in the mayor's reception room. Present at the meeting was Dr. Sands, Welfare Secretary Nellie Orr, architect Philip H. Johnson and director Cairns, who was receiving a good portion of the blame for Byberry and was anxious to clear the air. He still had a strong desire to see Byberry thrive and was not altogether devoted to the Machine. Mackey, however, had finally been cornered on the issue by a pressing group of civic leaders. In February, the Reverend Dr. Harry Burton Boyd, pastor of the Arch Street Presbyterian Church, slammed city officials for Byberry's condition from his pulpit. Speaking to his congregation, Boyd's statement was printed and subsequently broadcast on the radio. It reads as follows:

*No one is interested in cleaning up the mess, insane folks do not vote. The conditions at Byberry are a disgrace to Philadelphia. For several months Byberry has rested under a cloud. Charges both veiled and open have been made about conditions there. Two patients died under circumstances that call for investigation. The Director of Public Health promised to make any change necessary, then backed away from the mess. Mayor Mackey stated that the helpless insane should not be exploited. He promised to remove the lid. He did—took one look at the mess and then retreated. A committee of doctors was asked to investigate and report. Their report was naive and politic. In the meantime the City Controller began an audit of the books and uncovered irregularities and suggested changes in the personnel. His suggestions have been ignored.*

*No one can dispute that the hospital is overcrowded and understaffed with nurses and physicians. New buildings are needed and a larger support from city funds required. No one doubts that its complement of employees is filled with political hangers-on. Members of City Council go out of the way to destroy the morale of the police department. They publicly and in disgraceful fashion vent their political spite on the Director of Public Safety. In the meantime, the insane poor of the city and their relatives hold out their hands for pity. No members of City Council will champion their cause. The Mayor and Director of Public Health have abandoned them to their fate. Will the church members of Philadelphia keep silent any longer?*

Mackey responded to Boyd's charge with a somewhat pushy letter inviting Boyd to city hall to discuss the matter. He acted as a true Machine man, totally unafraid. Mackey almost threateningly told Boyd he would invite "the committee of ten physicians, who have just investigated those conditions," to "hear your criticism so that you may point out to them wherein their report was 'naive and politic' as you stated yesterday." Seeming to get angrier while dictating the letter to his stenographer, Mackey continued:

*I will ask the Controller to be here also, so that there will be no mistake about what his report to us is, and you can point out to Director Cairns and myself wherein we have "abandoned the insane patients and their relatives to their fate." You can point out in the presence of these responsible officials the facts upon which you base your conclusion, as you are quoted in the papers, that "no one is interested in actually*

*Left to right:* Dr. James P. Sands, Councilman Morris Apt and Director of Public Health J. Norman Henry, 1932. *Temple University Urban Archives.*

*cleaning up the mess," and that "the dependent insane have become victims of political jobbery."*

Boyd's response was humbler:

*Permit me to suggest that you act on the evidence directly in your hands before you call another conference. I do not question the kindness of your heart. I merely desire that you translate sentiment into action. When you are ready to act on the evidence you have I shall be glad to assist you to the best of my ability. Until then I respectfully decline to attend any conference on Byberry.*

Boyd wasn't the only one, however, who wanted an investigation. A loyal reformer, Dr. Cairns pressed for his own personal investigation. He called for changes in staff, new buildings and an accurate system of patient records. The results of his investigation turned up new cracks in Byberry's infrastructure. The number of staff proved highly inadequate for a hospital of 5,400 patients. The total number of qualified physicians on staff was fifteen. On the female side, it was found that only two physicians were in charge of 2,300 patients. There were no clinical positions on file, and the clinical duties were handled by the chief physician and his assistant. There was no consulting staff. With a total of 216 attendants, the attendant turnover rate was 40 percent. There was no adequate pharmacy department. The hospital's drug supply was handled by a single part-time employee who was only there several hours a day. There were three Hydro-Tubs for 2,300 females and six for 3,100 males. Pressing further, Cairns demanded city controller S. Davis Wilson—a seemingly loyal Machine man—to report on Byberry's financial situation.

The controller's report showed what everyone knew it would: gaps and shortages. The "effects fund" was made up of money taken from patients upon their commitments. It showed a shortage of over $1,600. The storeroom was terribly mismanaged, with no accounting system in place at all. When the auditors of the investigating committee requested a copy of the 1929 inventory, they were told it had disappeared—yet it mysteriously showed up two years later. It was found that $24,000 in supplies from the storehouse was stowed away in the basement of one of the farmhouses in the East Group, conveniently located only feet from Southampton Road. The payroll system was being taken advantage of, having only required a signature—apparently anyone's signature—to collect an attendant's wage. Wilson alluded to charges that Byberry had become an open market for the sale and use of alcohol. But whether Wilson felt any awkwardness is a curious point. Just a few short years earlier, Wilson himself had been palling around with the same men who had been dipping into Byberry's lifeline of funding for their own personal gain, and almost assuredly he had benefited in one way or another from the hospital's misery.

Nearing the close of Prohibition, Philadelphians' frustration with the Eighteenth Amendment showed. But the presence of liquor at Byberry was commonplace since its beginning. Attendants and doctors alike imbibed in drink during work hours. It is not difficult to sympathize with their self-medication. Since the law still allowed for licensed doctors to prescribe alcohol for medicinal purposes, Chief Resident Physician Dr. Samuel T.

Male attendants in uniform, possibly at the official opening in 1926. *Pennsylvania State Archives, RG-23.*

Gordy openly sold liquor to just about anyone who wanted it, patients and staff. However, Dr. Cairns's investigation disturbed the flow of alcohol at Byberry. In 1930, Gordy was promptly discharged and his prescription license revoked by the government after it was learned that he had prescribed more than four hundred pints of liquor in one year.

Mackey commented on the liquor dilemma. "I regret that the report of the sale of bootleg liquor to hospital patients has become public," he said. "According to Dr. Cairns's information, employees obtained the liquor from a bootleg place a short distance across the Bucks County line. As a result of premature publicity, the operators of the plant will probably shut down operations." Dr. Sands, having been unfairly given the bulk of the blame, fought back. "Can you tell me of any institution which has more than six hundred employees where liquor cannot be found?" he snapped. "For some reason or another, whether political or otherwise, Byberry seems to be singled out every two or three months or so for some sort of criticism. We are doing everything we can…"

Mackey dismissed twelve members of Byberry's staff when the results of the investigation hit his desk, including Dr. Gordy, whose salary was $4,000

Women's dining room, West Group. *Historical Society of Pennsylvania.*

a year. The hospital's appropriation for 1930 was less than it was for 1929, and staff cuts were inevitable. Dr. Sands complained that his views were not considered. Already realizing that he had stepped into a crooked system, he came out against the dismissals, saying, "Dr. Gordy was my right-hand man. I deeply regret his loss." Dr. Gordy was replaced in Febuary 1931 by Dr. Robert A. Matthews, who had been the chief physician for the East Group. Matthews took over the operation of the PIFM, at a salary of $4,000 a year. Meanwhile, Sands and Cairns pressed for a meeting with Mackey to discuss the reorganization of staff. The overcrowding was also discussed, and architect Johnson was on hand to defend his buildings.

"Ten million dollars is required to complete the group of buildings for the institution that I have designed, but two million dollars would take care of the overcrowded condition," said Johnson. "I could spend two million dollars in a year and a half and that would relieve the overcrowding." In true Machine talk, he continued. "Two million now would practically relieve that [overcrowded] condition. The buildings were originally designed to carry 6,000 people at an approximate cost of $10,000,000. However, if the

C-6 building, one of two buildings for tubercular female patients, 1937. *Pennsylvania State Archives, RG-23.*

$2,000,000 is appropriated, at the end of ten years the condition will then be as bad as it is today."

The meeting healed a few wounds but failed to solve anything. Dr. Sands continued as superintendent and began to build a psychology department. Meanwhile, the funds Mackey had managed to get from the DPHC were still being spent, and construction was still underway. Edward A. McNally, assistant superintendent, was dismissed as a result of the report, having proven to be the link to the Vare Machine. McNally was earning $1,500 a year at Byberry, where he spent a limited amount of time. The position was just a political doggie bag for McNally, and replacing him would be a big step out of the Machine's backyard. Taking his place was Raymond F. Johnston, an accountant for the Philadelphia Electric Company who, ironically (due to the company's Machine ties), came highly recommended.

## The End of Perpetuity

In March 1932, with the depression looming, Mayor J. Hampton Moore, serving his second stint in city hall, again pressed the issue of Johnson's

"perpetual contract." Upon the insistence of City Solicitor David J. Smyth, Moore instructed City Architect John P.B. Sinkler to design a new dormitory to house two hundred male patients at a cost of $272,000. Moore's plan was to proceed with the construction until Johnson sued. Many who were familiar with the Johnson contract expected his quick rebuttal. Knowing of Johnson's old tricks, it was assumed that he would either halt the process or alter the building as to receive his commission of $13,600. Speaking to the situation, Councilman Edward A. Kelly commented, "The other architects [Johnson] may change those plans. That is, he may change those plans completely, in fact, the entire aspect of the situation."

Director of Public Health Dr. J. Norman Henry felt he had no say in the matter. "I am afraid he is superior to the city architect in such matters," he said. Councilman Morris Apt was no more hopeful, stating, "No matter whose plans are adopted, the Bureau of Health architect will receive his commission just the same."

Johnson was on vacation in West Palm Beach, Florida, when he received the news. He immediately issued a response. "I shall stand by my contract rights. The authorization for hospital construction at Byberry has been given to me by ordinance of city council," Johnson flared. "My contract has been upheld by court test. Municipal buildings I have designed are the best evidence of my qualifications as an architect."

Johnson won his suit, and Sinkler's plans never saw brick or mortar. After this battle was over, the only real losers were again the patients. No new dormitory for males was built, but Johnson received his commission for Sinkler's unused design. Then, at an almost opportune time in 1933—the worst year of the Depression—Philip H. Johnson died of heart failure at sixty-five. He was attending a dinner in his honor thrown by fellow members of the Philadelphia Yacht Club when he was rushed to Taylor Hospital in Ridley Park, where he spent about two weeks being visited by friends, such as former DPHC director Wilmer Krusen. His wife, Margaret, had died in 1926, and the couple had no children.

Johnson's estate proved to be larger than anyone realized. He had managed to accumulate roughly $1.8 million in cash, as well as three yachts, property in Larchmont, New York (where he was also a member of the yacht club), and lavish properties in Center City, Chestnut Hill and Ridley Park. Johnson's death was surely a relief to many in city hall and in Harrisburg. They were finally rid of Johnson and his expensive contract. But by now, he had already designed over three hundred buildings for the city and state. The last structures of the building plan at Byberry had been completed two years

prior to Johnson's death, and they were already in poor physical condition, owing mainly to lack of maintenance and the cheap building materials that were used. Fortunately, the majority of Johnson's projects ultimately proved to be well-designed and well-built structures.

## THE WPA PERFORMS CPR

The Depression years at Byberry were, not surprisingly, the worst of all. The overcrowding reached a peak, and all but private charity hospitals were feeling the financial squeeze. From layoffs to supply cutbacks, every public hospital in the United States was showing bruising from the Depression's hits. But in Byberry's case, already battered from abuse, the Great Depression almost killed it. If it were not for President Roosevelt's Works Progress Administration (WPA), Byberry would have had almost no maintenance or improvements of any kind. The WPA did impressive work at the farm group and was responsible for paving most of the roads and sidewalks, land grading and construction of rain gutters, as well as structural and land improvements.

In 1933, a new infirmary was finally added, completing the West Group. Built entirely with WPA labor, the new building seemed immediately old-fashioned. It was built using Johnson's plans that were three decades old. Like the East Group's tubercular building, the new infirmary was minuscule in relation to the patient population. It was, like the rest of Johnson's cottages, two stories in height with a gabled roof and a terra cotta–trimmed frontispiece. Very basic in structure, it featured two large wings with a capacity for 130 beds and a rear entrance leading directly to a double-sided Otis elevator for fast medical access. The basement contained a library of medical textbooks and a pharmacy.

In 1934, WPA workers built a bridge over Byberry Creek and dug a pond to act as an overflow spillway and a pleasant scene for patients at the same time. Along with about a one-thousand-foot length of the creek, the manmade pond was lined around the edges with fieldstone, which was quarried out of the footprint of the pond itself. Completing the project was

*Opposite, top*: New infirmary for female patients (rear view), West Group. *Pennsylvania State Archives, RG-23*.

*Opposite, bottom*: Dental office in the new infirmary. *Pennsylvania State Archives, RG-23*.

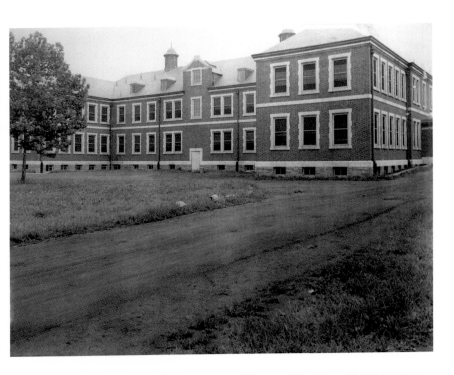

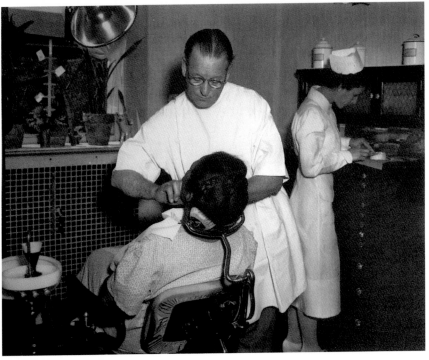

Architect's drawing of new children's dormitory (PIFM). *Temple University Urban Archives.*

a new underground root cellar. Cool water from the creek was rerouted via concrete passages to flow beneath the new root cellar. Using the flow of the freshwater, it acted as a natural air conditioner, keeping the hospital's harvest of vegetables and other goods fresh. The cellar was completed in 1941 and was capable of storing two hundred tons of produce. Only the bridge and pond still exist today.

In 1934, an unknown philanthropist donated $65,000 for the construction of Johnson's last building, the schoolhouse for the PIFM. Located on the west end of the cottage group, it was built on Johnson's outdated plans from decades ago using WPA labor. The building had been designed as a schoolhouse but was opened by the institution as a much-needed dormitory, containing an additional seventy beds. The simple, one-story stucco-covered brick-and-concrete structure matched the scheme of the group. It was 271 by 77 feet. Although not enough to cure the crowded population of children, the donation certainly eased it and showed that philanthropy had not yet vanished from the city. At the building's groundbreaking, Mayor Moore praised the donor, whose identity he insisted he did not know. "The erection of this building, generously donated to the city by a practical philanthropist, is an answer to the oft-discussed congestion at Byberry," he said. "The mind and sympathies of the donor run to the invalided [*sic*] children who are hopelessly sick and who must be cared for to the end of their time. I cannot name the good citizen who has come to the assistance of the taxpayers in this instance, but in their name, I can thank him for what he has done for the alleviation of distress in our community, and this I do most heartily."

## Pictures Don't Lie

J. David Stern, a warrior for labor unions and a devoted reformer, was also the owner of several local newspapers, including the *Philadelphia Record*. Stern was backed by Senator Harry Shapiro, who spearheaded an effort to publicize Byberry's situation. Upon Stern's insistence, *Record* photographer Mac Parker attempted to get permission from Dr. Sands to take photographs of the wards. He was denied. After two other failed attempts, Parker disguised himself as a WPA worker and easily gained entrance. Over the course of three weeks at the hospital, Parker photographed the conditions from the inside. He created a damning exposé for publication in the *Record*. Before his stint as mayor, City Controller S. Davis Wilson tried his hand at repairing Byberry's public image. His loyal colleague and friend, Deputy Attorney General S.M. O'Hara, suggested that the term "insane" be changed to "feeble-minded" in an attempt to modernize the public's attitude toward mental health. Wilson wanted to be "the good guy" at Byberry. He came up in the days of Mackey and Barr and most likely had a true desire to improve conditions there. But Parker's photos had prompted a new effort by Stern's *Record*.

Before publishing any of them, Stern sent more of his photographers in to expose Byberry's hidden conditions. In May 1938, *Record* photographer Martin Hyman, hired as an attendant, was assigned to building C, where it was suggested by Parker that three hundred men were kept naked indoors year-round due to lack of appropriations for clothing for them. Other newspapers called Stern's effort "intrusive" and refused to publish any reports of the alleged circumstances in building C. "It can't be as bad as all that," said one editor. "No civilized community would tolerate such conditions for a moment." But Hyman proceeded with his exposure of the building. Using a small Brownie camera held passively at his waist, Hyman snapped a few pictures candidly of the nude patients on the ward. The supervisor of male attendants watched Hyman closely, not without noticing his camera. He confronted Hyman and made him expose the film, assuring the photos would never be seen. But during his time on the ward, Hyman met other attendants who shared his sympathies. One attendant, assigned to building D, approached him while the supervisor was away from the ward and pledged to help Hyman expose the conditions at Byberry. The attendant was apparently a skilled hydro-therapist who cared more about the welfare of the patients than his job at Byberry. He explained to Hyman that building C was the incontinent

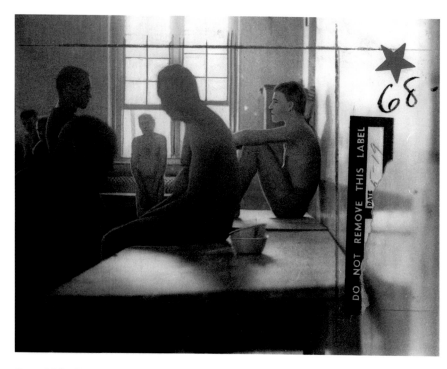

One of Mac Parker's "stolen" photos showing nude patients in building C, 1936. *Historical Society of Pennsylvania.*

ward. The patients living there suffered from an inability to control their bodily functions, and the lack of clothing was due to the constant soiling they received. The hospital's laundry, also understaffed, proved incapable of constantly cleaning the soiled linens of the three hundred men. The end result was an odor of urine and feces so strong that it engulfed the neighboring buildings. This earned building C a nickname among staff: the "Rose Garden."

The attendant made good on his word to Hyman and toured him through building C as he photographed the nude patients. The next morning, the attendant was fired. But after ten days, he was rehired. In an attempt to "punish" the attendant, he was reassigned to the "Rose Garden." Hyman urged that the story of his helpful new friend be told as part of the article. However, the attendant requested his name not be revealed. Whoever this attendant was, he deserves credit for his selfless efforts.

## Wilson's War

Samuel Davis Wilson, former city controller, was elected mayor in 1936. Wilson was one of Philadelphia's most colorful and interesting mayors. Though he always publicly acted as a foe of the Machine, his dealings with it were not unnoticed. His frequent flip-flopping on issues was not unique to his under-the-table politicking. He ran twice for a senate seat as a Democrat, losing both times. When he suddenly became a Republican mayoral candidate in 1935, he was eked into office by a narrow margin over Democrat John Kelly Sr. Then suddenly, under odd socio-political circumstances, Wilson appeared as a warrior for Byberry's betterment. But the actions of his administration seemed purely political. In February 1936, Wilson began his first investigation of Byberry as mayor. He assembled a committee to inspect the hospital and personally toured the buildings and grounds several times. He almost immediately announced the resignation of his political enemy, Dr. Sands. Wilson claimed that his removal of Sands was all business and that he had no personal motives, but it was hard to see it that way. Wilson's true reasons for removing Sands are not clear, but his decision seemed like another obvious flip-flop. Wilson said in a budget meeting that Sands showed "hostility" to his team during a previous inspection when he was controller.

"Dr. Sands will not be superintendent at Byberry after the first of the year," he had proclaimed months earlier. Sands saw obvious Machine politics in action. It only added weight to his charges when Wilson appointed Dr. Wilbur P. Rickert as "resident overseer," his personal representative. Wilson instructed Rickert to take residence on the grounds while his committee made its report. It seemed apparent that Wilson's plan from the beginning was to replace Sands with Rickert. Commenting publicly, Wilson stated, "I have asked Dr. Sands to resign because of sharp differences that have existed between us over the administration of the hospital for many years." During Wilson's time in office, he would participate in two more inspections of Byberry.

Wilbur P. Rickert was an ally of the Wilson administration through the Machine's involvement with the Pennsylvania Railroad. Big utility and transportation companies like the "Pennsy" had monopolized city hall in the 1920s, and they still held clout. But by 1935, the relationship had become very complicated. Rickert's appointment to the position, at $5,500 a year plus maintenance, looked like a political favor. The forty-six-year-old doctor graduated from the University of Pennsylvania Medical School in 1912 but

Mayor Wilson during the last of his several inspection tours in 1936. *Historical Society of Pennsylvania.*

had no notable training in the field of mental illness. Wilson's critics called Rickert his puppet and claimed he was placed into the position so that Wilson could keep a lid on the ever-growing Byberry problem. Compounding the lack of leadership was the peaking patient population. With an approved capacity for 3,600, the buildings were housing an unimaginable 7,000.

Rickert arrived with his wife in February 1936 and moved into the Stevens House. The first issue he took on was spilling off some of the overflowing patient census. Transfers were swift and forceful, as patients were sent as far away as Dixmont State Hospital, outside of Pittsburgh. Some were proven illegal aliens and sent back to their countries of origin. Others were found to be the responsibility of other counties in Pennsylvania and appropriately relocated. At Wilson's insistence, almost one thousand elderly male patients were sent to a homeless shelter at Eighteenth and Hamilton Streets, which had been set up a year earlier by his colleague. This was seen as another political favor, done at the expense of the comfort and safety of the patients.

Wilson's "cleanout" committee continued interviewing staff. They dismissed some and departmentalized others. "The reorganization will include transfers and replacements all the way down the line," Wilson said. Charging that Dr. Sands had assigned staff members the worst jobs as a form of punishment for lackluster job performance, Wilson stated, "The more arduous and disagreeable tasks will be rotated so they will not become a punishment to anyone." But in the shuffle, other horrors slipped out.

On May 15, 1938, Dr. Abraham Bozarjian arrived at his family's home at 2226 North Eleventh Street. The thirty-three-year-old dentist relaxed for a while with his two brothers and two sisters. Later, while they slept, Bozarjian used a meat cleaver to slash his siblings almost to death. He then set the house on fire, killing his sixty-two-year-old mother. Bozarjian had been admitted to Byberry after slashing the throat of a store clerk in 1935 and subsequently being found "criminally insane." He easily escaped several times and had been living with his family for two months. When police arrived at the scene, Bozarjian had stabbed himself in the abdomen with a kitchen knife. He was taken to Philadelphia General Hospital, where he was treated and immediately sent back to Byberry.

Superintendent Wilbur P. Rickert (right) observes WPA worker William Connelly repairing a wall, 1936. *Pennsylvania State Archives, RG-23.*

The Bozarjian family, of Armenian descent, had changed their name to Sarkis, leading to some confusion with police records. Rickert, backed by Mayor Wilson, put the blame on the family for housing him "illegally" for two months. "The real responsibility rests with the family," he said, "who failed to notify the hospital or the police. I hope this case will show the need for additional facilities at Byberry. A case like Bozarjian should never have been sent here at all because we can't keep them confined." Upon Bozarjian's return to building B, he learned from another patient that his sisters had survived his attack. Bozarjian was heard by a guard shouting, "Let me out of here so I can finish the job!"

## BREAKING POINT

By 1938, life at the hospital had deteriorated into chaos, the worst it would be for half a century. In July, the Machine's reform-resistant bubble around Byberry finally shattered under the pressure created by the Shapiro/Stern outcry. A *Chester Evening Times* article entitled "Phila Stirred Over Byberry Insane Cruelty" painted a horrific picture. It was worse than anyone thought. According to Shapiro, Byberry's was a "story of inefficiency, cruelty, intrigue, and barbarity, reminiscent of the dark ages." The Shapiro committee's report and subsequent grand jury investigation led to a legal battle. With a patient census of 5,400, Byberry was 300 percent overcrowded. Unless accompanied by disturbing images, the word "overcrowded" itself would not do much to shake up the public, and Stern knew it. Thanks to the "stolen" photos and Stern's insistence on printing them in his newspaper, Shapiro's committee had stone-cold proof of the barbaric treatment of Philadelphia's mentally ill, and they swung it at city hall with crippling force.

Shapiro pushed city council to act fast and give Byberry to the state before Machine lawyers found a way to lasso it back. He said that the hideous overcrowding was the "smallest part of the vice at Byberry" and that "all the money spent by the city on this institution might just as well be dumped in a cesspool for all the good it does. In Byberry, when an attendant beats a patient, apparently he gets a medal. The attendant disappears for three days, and then he comes back again." Shapiro's very public committee, combined with his small army of guerrilla photographers, cornered council. The public, many for the first time, saw the stomach-turning conditions at Byberry in their own living rooms. The

horrific photos accompanied by details of everyday patient life made the whole mid-Atlantic region cringe.

Politics certainly played a role in the move, as Wilson and Rickert claimed, but this time, it was on the side of the patients. For several political reasons, the Shapiro Committee narrowed in on Rickert as the "bad guy." The blame should have been distributed among a dozen employees, from the top down. But funneling it all onto Rickert achieved the same result necessarily, of state takeover, and caused more damage to a political enemy in the process. Shapiro pinned Byberry's problems on Rickert and "bum-rushed" him for the press. They recommended his immediate dismissal, along with three other physicians, who were hardly mentioned in the report. The investigators held him responsible for the following, as published in the *Chester Evening Times*:

> *Two hundred male patients were kept naked in one hospital building.*
>
> *Two women patients given "ground parole" became pregnant and were delivered of children.*
>
> *Some patients have been kept in straight-jackets three years and the straight-jacket is frequently used on others, although banned at modern institutions.*
>
> *Death of two patients—one by drowning during a bath treatment and the other by forced feeding—were reported as due to natural causes.*
>
> *Food is conveyed to patients on the same truck used for removing the dead.*
>
> *A cook for 350 feeble-minded children suffered from active tuberculosis and syphilis.*
>
> *Immoral practices and sex perversions are practiced among the children and between the children and male patients.*

Rickert was also charged with "building an intra-mural political system." The removal of 1,050 patients to other hospitals in the commonwealth was urged as the fastest way to ease the swollen, bloated municipal institution. Mayor Wilson himself immediately demanded the removal of the entire staff and suggested the appointment of his friend and then-superintendent of Philadelphia General Hospital Dr. William Turnbull to the position of chief of the Bureau of Hospitals. While some of the charges lobbed at Rickert were just, the majority were not fair. The committee's conglomeration of everything wrong with Byberry singled out the Machine superintendent as the lone culprit, thus exacting political revenge. However, doing away with Byberry's most crooked director was certainly a good move.

The report showed that there were an alarming six hundred deaths each year. Shapiro charged that half of the deaths were caused by the "negligence

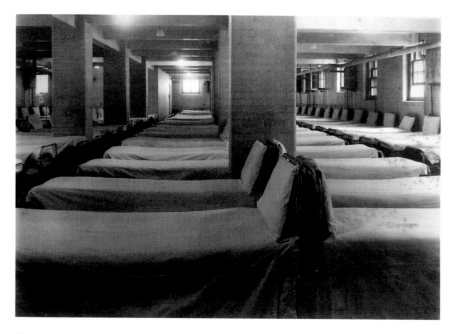

Overcrowded dormitory for 150 men in the basement of building F, circa 1938. *Pennsylvania State Archives, RG-23.*

and incompetence of the management." The Philadelphia County Medical Society blamed Rickert, claiming that due to "the gravity of present conditions at the institution," Rickert's removal was imperative given his "complete lack of training whatever for such a vitally important administrative position." Wilson, really feeling the pinch now, remained loyal to his railroad pals and put the blame on Clinical Director Frederick T. Zimmerman. He claimed Zimmerman was at fault for most of the conditions at Byberry. "I have been informed," said Wilson, "that Dr. Zimmerman has been the cause of most of the trouble at Byberry and that he is incompetent." Ironically, Wilson had appointed Zimmerman to the position himself in 1936.

"I come under civil service and will certainly resist an ouster move," responded Zimmerman. "I was appointed by Mayor Wilson two years ago at the start of his administration upon the recommendation of a special committee. I believe that the move to force me from office is due to the mayor's difference with the society's committee which recently reported on conditions at Byberry." At first, Zimmerman outright refused to resign in order to save his medical career. "I feel my own career is only incidental to the welfare of the 5,600 patients at Byberry who cannot speak for themselves," Zimmerman said. The opinion of the Medical Society was that Zimmerman

was one of the best psychiatrists at Byberry and that "his dismissal would leave the institution without a recognized trained psychiatrist and plunge it into further disorder."

Under added pressure from councilman and physician Arthur P. Keegan, who threatened him with impeachment unless he moved to "clean up the mess" at Byberry, Wilson put Turnbull in charge of the resignations of "all employees," but Turnbull was not exactly anxious to take on the position. "It is a dirty job, and I wouldn't do this for ten times what it is going to pay me," he said. "I am doing it only because it has been suggested that it is my duty." Fortunately for Turnbull, he would not get the chance, as Shapiro's committee and state takeover efforts were well on their way to becoming law. Finally, the old-schoolers were defeated, and Wilson found himself trapped under an aged and collapsing Philadelphia Republican Machine.

A committee of physicians from the County Medical Society, the Public Charities Association and the College of Physicians demanded Rickert's resignation. Each of the groups represented in the committee had reasons to stick it to Wilson under the floodlight of the Shapiro report. Wilson had made friends on both sides of the aisle, but his flip-flopping made him more enemies. He contended that Rickert's removal was an attack by a "group of medical-political-legal individuals who are peeved because I would not appoint a man they selected." On September 13, the Senate voted 30 to 7 in favor of Byberry's transfer, but with the continued backing of Wilson, Rickert refused to budge.

On October 15, 1938, at 10:00 a.m., a caravan carrying a small army of official-looking men proceeded through Byberry's front gate and up to the administration building. Leading them was State Welfare Secretary Charles I. Engard. Following behind him were twelve state troopers and twenty-five welfare officials, doctors and mental health professionals. They included Dr. Herbert C. Woolley of Pennhurst, Charles A. Zeller of Fairview State Hospital and Dr. Arthur P. Noyes of Norristown. Rickert must have been nervous as he watched them pull up the long, tree-lined driveway. He immediately called Mayor Wilson, who commanded him to stay put. Engard made his way into Rickert's office and, after talking with him for five minutes, dismissed the controversial superintendent and had him escorted off the property.

Wilson hit back, calling attention to the injunction suit still in the courts. Engard seemed oblivious to the suit's threats. He appointed William C. Sandy as acting superintendent and began interviews with the staff, stating, "Dr. Rickert will be the only change in the hospital staff at the present

State troopers at the gate during Rickert's removal in 1938. *Historical Society of Pennsylvania.*

time, and all employees will remain as state employees, at least until their competency has been checked." It soon became very clear to Wilson that the outdated city charter bylaws he had as a defense against state takeover were too flimsy to take into battle. It was also clear to him that unless a court

Dix Drive, the entrance driveway to the West Group administration building, circa 1956. *Pennsylvania State Archives, RG-23.*

order was issued, Engard was not about to let go of Byberry. On October 21, Dauphin County Court judge Karl E. Richards lifted the injunction, and the state began moving in and cleaning up.

Groundbreaking ceremony for S-1 building, 1941. *Historical Society of Pennsylvania.*

Chapter 5

# THE PHILADELPHIA STATE HOSPITAL

## The State Years

### WILSON SETS BYBERRY FREE

The efforts of the Shapiro/Stern reform movement had rocked Byberry's foundation. Changing times and advancements in technology being applied to new laws by new departments like the Federal Bureau of Investigations marked the beginning of the Machine's slow downward spiral out of existence. Governor Gifford Pinchot's successfully coordinated crippling of the Machine left Boss Vare broken and bitter but not friendless. He died soon afterward in 1934. The last of Philadelphia's real "bosses," William Vare left quite an impact. He also left a legacy of graft not since matched in Philadelphia, though others have tried.

As the Shapiro Bill was building, so were charges against Mayor Wilson of everything from racketeering to soliciting prostitutes. Probably fired at Wilson from Machine-loyal parties, they were supposed to be revenge for his political party flip-flopping. While never amounting to much other than newspaper splashes, the charges against Wilson were doing visible harm to his reputation. Wilson, however, carefully jumping around some of the charges while confronting others, did have some skeletons in his closet. But between fighting off charges, appealing for a Senate seat and running what was left of the Machine's decades-old policies he had inherited, Wilson was starting to sink. His grip soon loosened even more when his health began to fail.

Striking when the iron was hot, Shapiro's team was finally able to force Wilson to let go of thirteen city-run hospitals, with the showcase being Byberry. Mayor Wilson was a natural politician. He was good at his job, though he did not seem to enjoy it much. Weary from politics, pressures and his rapidly declining health, Wilson threw in the towel in August 1938. The time had come for Wilson to face his own Byberry demons. Having certainly been responsible for some of its situation or, at the least, not working hard enough to fix it, Wilson finally did the morally correct thing. Against the pleas of the Machine, he signed away city ownership of the dying institution.

Finally, on September 23, 1938, surrounded by a shining Senator Harry Shapiro, Dr. Camilla Anderson of the Public Charities Association, State Representative Paul Lewis and State Secretary of Welfare Charles I. Engard, Governor George Earle signed Shapiro's bill, officially placing Byberry under State care. By this time, almost 90 percent of the nation's public mental hospitals were state-managed institutions. After the transfer, the state had no plans for the other twelve Philadelphia hospitals it was now in charge of. Shapiro's bill had existed solely for the reform of Byberry. It could not, however, have consisted only of Byberry. The other hospitals were thrown into the bill in order for the state to even consider looking at it. The Machine still had loyal members in Harrisburg who tried to the end to prevent its loss of control of the "Byberry Bank." Thankfully, they failed. But the Machine was still mostly in place in Harrisburg and Philadelphia, and it wasn't letting go without a fight.

Wilson's soul-searched decision ruined many opportunities for aspiring grafters in Philadelphia, and he became loathed in some previous circles. However, Wilson conveniently died a month later and took his "back-and-forth" reputation with him. His public image had been tarnished, but in a deathbed act of redemption, he unlocked Byberry's chains. Unfortunately, many of Wilson's humanitarian acts were overlooked as the mounting charges against him finalized his status. The airport he fought hard to construct—the S. Davis Wilson Airport—was eventually torn down, and there is no statue or park in his name. As punishment by the Machine for loosing his grip on their empire of corruption, little remains in Philadelphia as tribute to one of its most interesting mayoral figures.

## WOOLLEY GETS TO WORK

The hospital was about 300 percent overcrowded at the time of the state takeover, which was, fortunately, the worst number it would see. The state

Woolley assumes superintendency, 1938. *Left to right:* Dr. Charles A. Zeller, Charles I. Engard, Dr. Arthur P. Noyes (standing), Dr. Herbert C. Woolley and Dr. William C. Sandy. *Historical Society of Pennsylvania.*

was ready and responded with a comprehensive new building plan and a group of qualified staff that it put in place. Gathering together the State's top officials in the field of mental health, another committee was formed to determine the best course of action. This committee consisted of superintendents of Pennsylvania's state hospitals from Allentown to Warren, as well as Dr. Cairns and Dr. Sands. Also present was prison inspector and future Byberry hero Furey Ellis.

At the time, Ellis had just finished a tiring fight against the authorities of Holmesburg Prison over their inhumane treatment of prisoners in their "Klondike cells," or punishment cells. They were small and windowless, located three feet from a large steam pipe. The guards would increase the steam flow through the pipe, creating an environment so hot that it caused the deaths of at least four inmates. The Board of Corrections still consisted of loyal but powerless Machine men. Ellis saw to it that the administration was replaced and the cells demolished. The dying Machine would never again have a hand in the city's prison system, which it had ruled since its inception. With this victory, Ellis began earning his

reputation as a tough reformer, not for sale and clearly not afraid to take on the old powers.

Governor Earle was a reformer who had come up during the Machine's reign of Philadelphia. He had been aware of the Byberry problem for some time, but getting to the bottom of the corruption at Byberry was no easy task, even for the State. After a thorough vetting, Earle appointed a new Board of Trustees for Byberry. Its chairman was former state attorney general William A. Schnader. The new board also included psychiatrist Earl D. Bond, Dr. Wilmer Krusen, attorney Thomas Evans, congressman Frank J.G. Dorsey, accountant for the Democratic City Committee William H. Godfrey, State Representative Paul C. Lewis and local businessman Victor Moore.

The first state-appointed superintendent was Dr. Herbert C. Woolley, of Pennhurst State School. Woolley seemed the clear choice for a new beginning at Byberry, and his appointment was hinted at for months prior to its fruition. Woolley was a noted figure in the field of mental health. He served in the First World War, graduated from Jefferson Medical College and served as the assistant superintendent at St. Elizabeth's Hospital in Washington, D.C. He became the superintendent at Pennhurst in 1937 and was particularly esteemed for improving the conditions there in just over a year. The underfunded hospital in Spring City had gone through eleven superintendents in the last twenty years. It was believed to have been experiencing problems similar to that of Byberry.

When first questioned about taking over the administration of Byberry, Woolley replied, "I am not an applicant for the position at Byberry, and I am not a candidate. Of course, if my superiors order me there I will consider it." Whether by choice or by direct order, Woolley moved into his new home at the Stevens House in October 1938, full of fight and ready to tackle Byberry. "I have had twenty-five years experience and I expect to operate this institution according to the standards of the State Department of Welfare," he said. "I expect full cooperation from everyone in the hospital, and I believe everything will go along smoothly." Upon his arrival, Woolley posted his pledge for a new set of standards for all employees and competent patients to see. It read, in part:

> *The hospital will be known as the Philadelphia State Hospital and its objective will be the most humane and modern treatment of the mentally ill. Employees of all grades are invited to carry on with this objective in view. Partisan politics and human misery are not compatible. Therefore, political activity on the part of all ranks is proscribed.*

Beds for three hundred men in building A. *Historical Society of Pennsylvania.*

*Dismissals from the institutional service will be made only for a cause.*
*Abuse of patients, mental, moral or physical, is the unpardonable sin of*
*mental hospitals and will neither be tolerated nor condoned.*

A mere month later, he reported the situation as "hopeless" and claimed he had inherited a "medieval pesthouse." He was, however, able to raise its standards to "the equivalent of a seventeenth-century asylum." Woolley himself admitted that the only real way to solve the problem at Byberry was new buildings—and a lot of them. He did succeed in correcting, as he put it, many basic evils. In March 1939, Woolley ordered six hundred double-decker beds to use in the male group. "Although nothing but new buildings can correct entirely the overcrowding," he said, "the double-deckers, plus nine-hundred single cots, will help bring a measure of relief to our 5,560 patients, thankfully down from 7,000. I want everyone to know of my institution's need. Philadelphia State Hospital belongs to the taxpayers, and it is up to them to make it as fine a mind-restoring place as it can be."

Woolley did what he could to develop extracurricular and recreational activities for his patients. Although his budget allowed for very little hospital-

sponsored patient recreation, Woolley found other ways. In 1939, for example, he was more than happy to allow charitable bandleader Vincent Lopez to experiment at Byberry with what he called "swing therapy." Lopez claimed that the stimulation caused by live music was a real form of therapy and should be treated as such. After playing to four hundred cheering, clapping patients, Lopez said, "Jitterbugs gave me the idea. I concluded that if a jam session excited sane youngsters into a frenzy of wild antics and weird gyrations, then certainly it would be worth experimenting to see what effect the strong, primitive vibrations of a swing band would have on mental patients."

The presence of Lopez and his band at Byberry drew the press, and Woolley used the occasion to boost public morale on Byberry. "There is so much that we don't know about treating mental disorders that we are willing to try anything," he mused. "Who knows? Perhaps swing music will

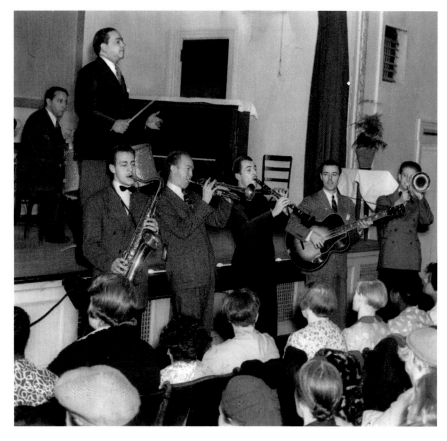

Vincent Lopez demonstrates his "Swing Therapy" method on ecstatic female patients in 1939. *Historical Society of Pennsylvania.*

set off a spark in some patients that may lead to complete recovery." After Byberry, Lopez took his swing therapy to other institutions and achieved positive results.

Woolley made very public his criticisms of the hospital to avoid ending up in the awkward position of his predecessors. He called attention to the physical character of the buildings. "Bathing facilities are insufficient and inadequate, the shower heads frequently being empty cans with holes punched therein. Floors are worn out and actually dangerous in places. Scrub water runs through to the floor below. On some wards, the floors give like thin ice as one walks across. Cracks are wide and collectors of dirt. The ward dining rooms are, for the most part, disgusting both in appearance and odor. In fact, there is only one English word that describes the smell, and that is 'stink.'"

The new superintendent also spoke of the hospital's staff, whom he called mostly inadequate. The staff-to-patient ratio was at a miserable low of 1 to 193. When inquired as to his opinion of Stern's exposure of the hundreds of nude patients and the lack of clothing, Woolley replied, "Sufficient clothing of any description was not available to relieve the crowded condition of

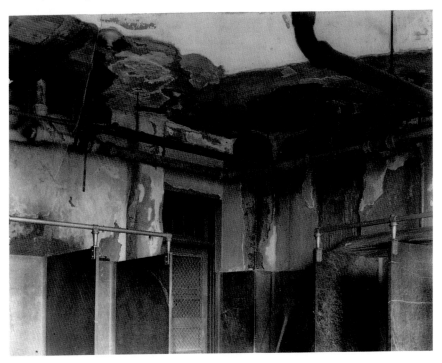

Shower facilities, East Group. *Historical Society of Pennsylvania.*

the wards by taking the patients out of doors in fine weather to say nothing of cold weather out-of-doors exercise, and at times, ambulatory patients could not go to the general dining room because of nakedness." Woolley also pointed out that total supplies for the year amounted to $85,279, or a pitiful four cents per patient. He reported that the social service staff were all dismissed by force for lack of submitting their resignations. "The greatest value of this place now is negative," he said. "It shows how a hospital should NOT be run."

## Making a Modern Hospital

Concluded in the Shapiro committee's report was its recommendations for modern buildings, rehabilitation of Johnson's existing buildings and a complete redesign of the hospital's infrastructure. The first thing the state calculated was the cost of the buildings and the number of new staff their operation would require. But most of all, it needed to be determined how much the new hospital would cost to run. The answer was, by 1938 figures, about $2 million a year. The General State Authority (GSA) began accepting bids for the new buildings at Byberry in 1939. It appropriated $7.5 million for construction. In 1940, the board accepted the designs of George Wharton Pepper Jr. and moved the project forward.

Son of City Councilman George and grandson of University of Pennsylvania provost William, Pepper had been a semi-successful architect as part of the firm Tilden, Pepper and Register. It was most likely his family connections that boosted his career with a large number of contracts for the GSA, resulting in his departure from that firm. As an official GSA architect, Pepper designed many buildings at state hospitals in Pennsylvania during the 1940s. He also designed schools and other public buildings. Pepper's revised building plan from 1940 shows a small city. It called for the construction of almost fifty new buildings, sprawling across three-quarters of the hospital's almost one thousand acres. Of these proposed buildings, only about an eighth would come to be constructed. Continuing the 6 percent commission system, Pepper would have upward of $300,000 coming his way.

Aside from Pepper, other firms such as Ballinger and Co., Davis and Poole and Day and Zimmerman submitted plans for buildings. Day and Zimmerman performed a geographical survey of the property in 1940, for which it was paid $25,000. The Ballinger firm had drawn up plans for

new buildings in conjunction with a WPA contract in 1938. But by 1941, the contract had gone stale, and Pepper inherited the entire project. This immediately looked like a replay of the Johnson scandal and began to raise questions. GSA director David Diehl responded, making it clear that the contract was on the level. "There is no assurance that Pepper will be the only architect engaged, he has not been given a blanket commission for the project," Diehl said. "He has been engaged to do whatever the Authority assigns to him. He will work in cooperation with our architects and engineers."

Maintaining the same basic group layout, the State's plan called for the addition of a North Group. This inadvertently, due to geographic boundaries, caused the former West Group (women's group) to be re-designated as the Central Group, or "C" buildings, as two new building groups were to be erected north and south of it. They also were to receive thorough renovations and repairs. The South Group, in addition to the existing children's cottages and Nurses and Attendants' Home, would contain the various new building for staff housing. A two-story addition was planned for the existing Nurses and Female Attendants' Home to make room for 350 more. The East Group, aside from renovations of existing buildings, was not to receive much modern attention. Fireproof garages and a warehouse for the hospital's supplies built along the connecting railroad line to the west power plant were also in the works.

Construction of the commonwealth's new buildings at Byberry marked an inspiring new attitude toward Philadelphia's treatment of its mentally challenged population. The new Republican reform governor Arthur James

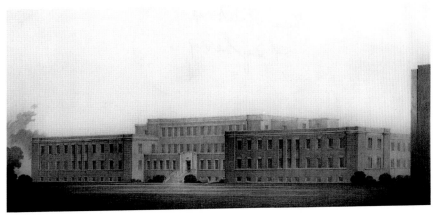

Architect's drawing of S-1 building. *Historical Society of Pennsylvania.*

carried on the construction process publicly and openly, and the future looked bright for Byberry. The first building the State erected was the "Workers' Building," a building for working patients. The building was designated "S-1" building on Pepper's plans, as it was located in the South Group, below the children's cottages (PIFM), west of Route 1. It would contain a cafeteria, a library and 350 beds. This impressive two-story building, like the rest of the buildings planned, was very general in appearance. Governor James himself broke the ground in 1941 to the roars of hundreds of guests, and the construction began.

## The Busy Coroner

Byberry was becoming less threatening in the newspapers, which now showed photographs of building construction rather than human destruction, and the public briefly began to embrace the "new" institution. Woolley seemed to be living up to his reputation, and attitudes were changing. Some thought Byberry really could be turned around. But on Christmas Day 1940, the beating death of an inmate, former police officer Paul Hallowell, busted Woolley's bubble. His hopeful attitude seemed to drop away quickly, and he was soon condemning Byberry as "a disgrace to any community or government which calls itself civilized."

Sixty-two-year-old Hallowell, being the fifth case from Byberry that Coroner Charles H. Hersch received in two months labeled by hospital staff as "accidental," caused an investigation. It was learned that Hallowell's caregiver, Russell Brough, was on parole from the State Industrial School and was quickly discharged. Hallowell died two days later. The other four patients who died under "mysterious" circumstances were Jacob Nonamacker, David Chodnowsky, William J. Williamson and Grant Wimberly. They were all over sixty years old.

"It is unfortunate that loose talk, insinuations, innuendos, and aspirations can destroy in a few minutes the two years' efforts of a loyal, unselfish, tireless personnel to build public confidence and good will," said Woolley, in response to the investigation. But Byberry was back in the black. Hersch came down hard on the institution and its new administration. The four other deaths came under tight scrutiny, and for the first time, Woolley was feeling the public's attacks, unfair as they were. Woolley himself had once critiqued previous Byberry superintendents, but now he understood their

dilemma and acted as transparent as possible. "Any official is welcome to conduct any investigation that he cares to," he told investigators.

Hersch's investigation led State Welfare Secretary Arthur E. Sweeney to call in the state police. Every employee was fingerprinted and examined for criminal records. "There is something radically wrong at Byberry as revealed by these 'accidental' deaths," Hersch said. His office interviewed patients and staff, but few were willing to discuss what happened for fear of their own safety. Some patients mentioned a staff member they referred to as "the slugger of Byberry." A former boxing champion, he used his brute strength to control patients. Hersch's investigation seemed to lead nowhere.

Woolley was soon absolved of any wrongdoing by Hersch and his committee, who instead put the blame on "some official in Harrisburg" they could not identify. However, the committee spared little indulgence in their fantastical proposal of a $27-million reconstruction program. They also praised Woolley for turning the institution around and called its transformation miraculous. "In my opinion, Dr. Woolley is doing all that he can with the equipment at hand and is not responsible for the appalling conditions," reported Hersch. Woolley had reduced the hospital's number of straitjackets from 1,200 to 4 and reduced the number of patients by over one thousand.

Less than two months later, in March 1941, another beating death made headlines. Hersch, still stewing, instructed the police to detain the involved staff members immediately. Four attendants were arrested and charged with aggravated assault and involuntary manslaughter after an African American patient, thirty-two-year-old John Smith, was severely beaten, ultimately fatally, on his ward. Hersch this time involved a grand jury after he discovered bruising, broken ribs and internal bleeding at Smith's autopsy. At trial, Smith's sister gave tragic testimony that he spoke of the attack before dying at the hospital.

"They tried to kill me," Smith told her. "They kicked me and walked on me. Now they're trying to patch me up, but I'll never make it." After months of trial, charges on three of the four attendants in question were reduced to fines after one of them—William Cotonis—pled guilty to involuntary manslaughter and was sentenced to one year in prison. *Bulletin* writer Paul F. Ellis reported that out of the 281 employees that had been discharged since Woolley's arrival, over 200 were fired for mistreatment or abuse and the rest for drunkenness.

Due to the bad timing of these deaths, smack in the middle of the hospital's redevelopment, they seemed to stick out as sharp points of notoriety that lent

heavily to Byberry's horrible reputation. Unfortunately, the newspapers were almost automatically biased to the Byberry situation by now, and the true predicaments in which attendants found themselves were rarely expanded on or given much merit. More than likely, in many of the cases of attendants beating or murdering patients, self-defense was a plausible argument indeed.

Record writer Norman Abbott was one of the few who took the attendants' hazards into consideration. He called attention to the working conditions facing them in his article "The 'Why' at Byberry." Attendants, noted Abbott, if they chose the option to live on the grounds, earned fifty-five dollars a month for fifty-hour workweeks. Their living quarters were in no better physical condition than the patients' dormitories and not much less crowded. The food they lived on was the same food the patients had to tolerate.

According to Abbott, the job of attendant at Byberry was very easy to obtain. Although certain criteria were in place, such as criminal history, the hospital took everyone who applied. Theoretically, if a new attendant was hired, they would sign a pledge not to take advantage of patients, which was custom at most hospitals. But as Abbott points out, Byberry was no ordinary hospital. He wrote about a theoretical new attendant's first day on the job in building B, which housed 325 violent male patients and had an average of six attendants on duty at a time. The two wings of Johnson's antiquated and battered building B were being used as day rooms, and the beds were in the wet, dank basement. The day rooms were just as grim. The decorative wood floor had been ripped up and removed after being used as a weapon by patients. In fact, claimed the unit supervisor, the patients will use anything they can as a weapon. In the 1920s, patients in the East Group were given silverware at mealtimes, but that proved too dangerous. Now most of the male patients ate with their hands.

Abbott's theoretical new hire, provided he lasted past the orientation, would go through a ten-week training period, where films and lectures were presumed to acquaint him with his new position. But after completion of training (and often before), the new attendant was thrown to his own devices amid 325 violent, insane men who were also hungry…and frustrated. The imaginable conclusion seemed comparable to a warlike experience. Attendants ran and hugged the walls or used a baseball bat (housed for this purpose in the nurse's station) to get across the crowded dayroom to the exit. The descriptions alone are enough to get the nerves pumping. Compared with the tiny wages the job paid, it is very easy to see why the reputation of the position kept most from even considering it. In Byberry's case, at least in

B building, the inmates were running the asylum. But, as Abbott concluded in his article, "if there were 40 insane to a ward instead of 325; if there were plenty of attendants instead of half the required number; if insane could be sent to the hospital to be treated instead of merely confined, then—Byberry would not be Byberry."

One of the most important steps to making Byberry a decent hospital, Woolley said, was the appointment of a new board of trustees. He urged that the new board be made up of psychiatrists and superintendents of other state hospitals instead of "political buzzards." Byberry was at this time the third-largest mental hospital in the country, containing almost 6,200 patients. New York's Pilgrim State Hospital was the largest, with about 9,500. But even with such massive numbers, Pilgrim never reached the hideous reputation that Byberry already displayed. In 1941, Welfare Secretary Arthur Sweeny announced that Byberry's death rate was 8 per week. The year 1940 saw a total of 419 deaths at the hospital, but Sweeny explained that this was normal. "When you have 5,500 patients in a place like Byberry, most of whom are well up in years, it is not surprising that the mortality rate is high," he said. "Many of the patients at Byberry are senile when they're taken to the institution. Mental disorders are more prevalent in older people, and therefore the mortality rate in mental hospitals is much higher than it is in other types of institutions."

As the war loomed over the heads of Americans, Byberry's problems seemed less important. Woolley was getting tired of defending his hospital against a constantly nagging public who had no real comprehension of what it went through. Having exhausted himself improving his beloved Byberry, Woolley was done fighting what he called an impossible state budget and submitted his resignation to the board. It read:

> *It is with considerable regret that I feel impelled to submit my resignation, to take effect August 31, 1941. In taking this step may I express to the board individually and collectively my deep appreciation for the courtesy, consideration and support I have received. May I also make a matter of record my deep indebtedness and appreciation to my assistants on the medical, administrative, and nursing staffs of this hospital.*

The sixty-year-old superintendent had no problem admitting his desire for some leisure time. "I'm taking a long vacation," he said. "I bought a boat a few months ago, and I'm going to take a cruise."

## THE EFFECTS OF WAR

Dr. Charles Adam Zeller had earned himself a serious reputation in the mental health field long before coming to Byberry. He had plenty of experience as superintendent of Danville State Hospital before moving on to Farview State Hospital for Criminal Insane in Wayne County. Zeller's father was a physician, and he sometimes took young Charles along on calls to their local asylum near Scranton. He claimed it was during one of these visits, at age twelve, that he decided he wanted to work with the mentally ill. Along with Zeller came a new clinical director, Dr. Eugene Sielke. Sielke had worked alongside Zeller before at Danville, and they made a great team.

Appearing confident and knowledgeable as he placed a copy of the *Philadelphia Record* into the cornerstone of S-1 building at its opening ceremony, Zeller was showing signs of being a good administrator. While his sense of character reassured the board of his experience, the forty-three-year-old doctor gave the credit to Woolley. He said that the situation had been much improved by Woolley and that he merely had to maintain it. He

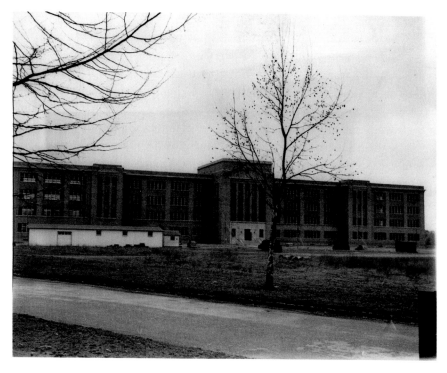

N-6 building nearing completion in 1944. *Historical Society of Pennsylvania.*

was, however, realistic about what faced him. "I'm no magician," he said. "And I don't expect to work any miracles. It's time to quit criticizing Byberry and instead to strive to build it up." But the building plan barely reached a moving pace when the Japanese attack on Pearl Harbor quickly washed Byberry from the headlines. Although construction continued, the positive public showcasing of the new hospital seriously lost its momentum.

In 1942 the GSA broke ground for two new dormitories. Located in the North Group (Carter tract), these two large, four-story dormitories resembled hotels. They were spacious, attractive and contrasted boldly with the Colonial Revival cottages of the West Group, just feet away. They were designated N-6 and N-7. Pepper's extensive plan called for almost fifty new buildings. The GSA approved funding for one or two buildings at a time, and N-6 and N-7 were the first patient buildings it chose to erect. The buildings' numerical designations on Pepper's plan simply signified the order in which he drew them, not the GSA's construction sequence or level of importance. As a result, many buildings were never erected, such as N-1 or N-2. After a slow construction process, N-6 and N-7 finally opened for operation in 1944. After their official opening, further construction was halted due to wartime material shortages.

By March 1944, the war had left Byberry with 127 less employees, from doctors to attendants to cooks. Dr. Zeller appealed to the draft board to take into consideration Byberry's desperate need of attendants and spoke publicly of the devastating effect on his hospital. "The public must awake to the realization that something must be done for our state institutions," he said. "The draft boards give us practically no deferments, and they recently told one of the few remaining male nurses we have that he must obtain essential employment or be drafted." It seemed, however, that many had enlisted, perhaps to get away from the hospital, and only a few were drafted.

## Send in the COs

The war affected Byberry in numerous ways. Construction came to a halt, and many of its young attendants were drafted or enlisted. The amount of the hospital's low-wage positions went from few to almost none. But there were those who kept Byberry afloat: conscientious objectors. It was estimated that forty thousand men nationwide legally avoided combat through their religious beliefs and instead became conscientious objectors

(COs). They were given civil service jobs and placed into positions to fill the void left by the war. The majority of COs from Philadelphia were Quakers, and about forty were sent to Byberry as attendants. In 1942, two such men, Warren Sawyer and Charles Lord, arrived and were immediately shocked and terrified by their new daily routine.

As they began to adjust to their roles, they realized the severity of the situation at Byberry. They had never seen anything so barbaric. They witnessed attendants using brutal force to restrain patients and described some of their tools—pipes, broom handles and pieces of fire hose filled with buckshot. Other methods were also described, such as choking a patient with a wet towel. "It left no marks on them," Sawyer recalled. He wrote letters home telling of dangerous encounters with violent patients. "I was in 'B' building, the death house," he wrote. "Due to the shortage of cuffs and straps and restraint locks, one of the patients was able to get himself loose. He was a very dangerous fellow. He had a spoon that had been broken off at the end and was sharpened almost to a knife edge. After he was loose, he went to another patient and jabbed him in the side of the neck on top of his shoulder and drove the spoon down about one inch deep, just missing the jugular vein." Sawyer and the other COs at Byberry were in a war of their own and not only with violent patients. The buildings of the East Group presented dangers themselves. Sawyer described his time in the "Rose Garden." "In the incontinent ward, it took a few weeks before you were used to eating supper with the smell all through your clothes and everything." He explained that even rigorous washing would not take the smell from his clothes.

When Charles Lord was put to work in the "Rose Garden," he immediately saw an opportunity. An amateur photographer, Lord began sneaking in his compact Agfa camera and documenting the disturbing sight. "I would try to fill the frame, you know, not just have little people far away," he said. "I'd get up as close as I could. I was aware of composition, but the main thing was to show the truth." Lord also photographed the violent patients in building B and, after filling up three rolls of film, showed them to anyone who would look. The Byberry COs formed an advocacy group of their own and, in 1945, arranged a meeting with First Lady Eleanor Roosevelt. Lord's photos were presented to the First Lady, who doubted their authenticity. She believed the photos were taken in a hospital in the south where, as she said, such conditions exist. But when she learned that the photos were actually taken in Philadelphia, she pledged her commitment to reform the conditions. Lord's photos were circulated around the country, and real awareness was finally achieved. Although he was not the first to capture Byberry's chaos

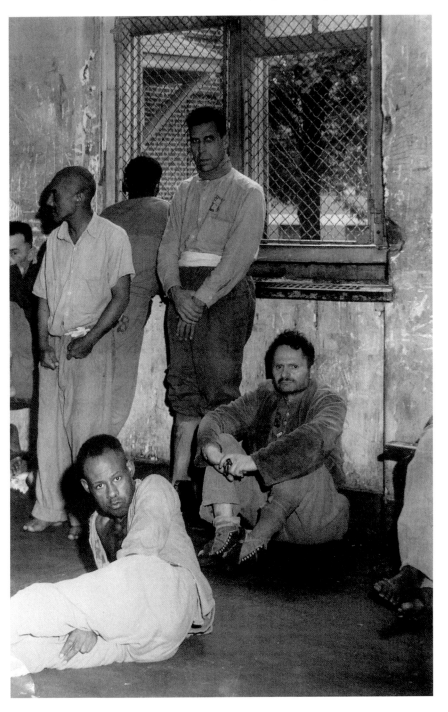

Patients in building B—the violent ward—in 1946. *Temple University Urban Archives.*

on film, Lord is credited as being one of the earliest photographers to successfully bring about national awareness through his work. Syracuse University professor Steven Taylor commented years later on the photos. "The immediate reaction by many people to these photographs were that they looked like Nazi concentration camps," he said. "People could not believe that this was the way we treated people with mental illness. So it created a kind of mass uproar nationally."

## POSTWAR CHANGES

When the material shortage was lifted in 1945, ground was broken for building N-5, the main dining hall for the North Group. It contained several large cafeterias for both patients and staff, modern kitchen facilities and staff lounges. It was also designed with a recreation room and a patient commissary. The building's basement was connected to the tunnel system,

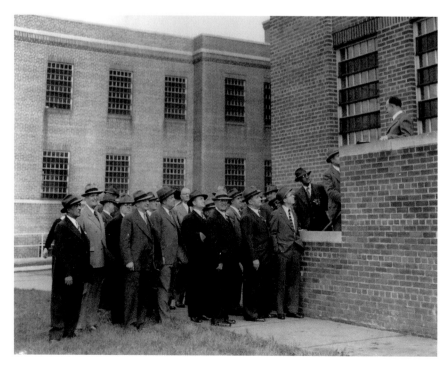

Sielke's press tour of S-1, 1946. *Temple University Urban Archives.*

Escaped patient Charles Watts after apprehension in 1946. *Historical Society of Pennsylvania.*

providing passage to N-6 and N-7, and patients could easily reach the new cafeteria without ever going outside.

Zeller held onto the reigns throughout the war years and through the completion of three new buildings. Because his years at Byberry coincided almost exactly with America's time at war, Zeller's progress went largely unappreciated, but not in the medical field. He was offered the position of Michigan Director of Mental Health, a position for which he was more than happy to leave Byberry. He submitted his resignation, effective February 28, 1946. His position would naturally be filled by his friend and colleague Dr. Sielke. Before he left however, Zeller warned of Byberry's dangers.

"Don't move away from the gaurds," he told *Record* reporter Julia Shawell, as he led her on a tour through building B. "It's a disgrace." He made no attempt to hold back his recommendations for Byberry's future, calling for new buildings and higher-paid staff. "There's a criminal potential in every mental case, and there are thousands waiting for admission who should be committed," he said. "The criminals and mental cases of tomorrow are in classrooms today."

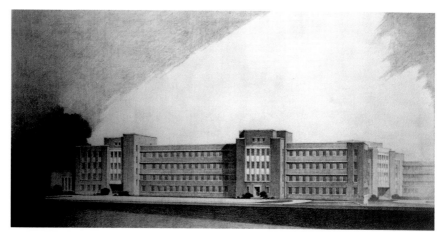

Architect's drawing of N-3. *Pennsylvania State Archives, RG-23.*

Dr. Eugene L. Sielke took control of Byberry on March 1, 1946. A native of Bethlehem, Sielke was a graduate of Columbia University and had been working under Zeller at Byberry. During his first week, he pulled the press into the institution with him, appealing to the public to convince legislators to increase Byberry's funding. Leading cameramen and reporters through the wards, he noted that only a small handful of devoted employees held the hospital together during the war. "Until Philadelphians realize what deplorable conditions exist," he said, "and until they make the legislature take some sort of action, Philadelphia will never have a decent hospital at Byberry."

With a population of 6,110 patients crammed into buildings built for 3,500, Sielke was definitely justified in his longing for funds. He reported that 148 attendants were doing the work of 800, and 80 of them were COs who would be gone by May. "It is estimated that it would take about $46,000,000 to put Byberry into shape," he said. "And this estimate was made three years ago. It would cost more now." Between December 1938 and June 1942, the state spent $5,378,676.92 on the construction of S-1, N-6 and N-7.

In April 1946, Sielke was interrupted by more press after escaped inmate Charles Watts caused a panic at the Liberty Bell Trailer Camp, about a half mile north on Route 1. In his second escape in two days, twenty-three-year-old Watts entered the trailer park and broke into a trailer. Inside he attacked a woman, tearing her clothes and scratching her face. The woman's husband was able to subdue Watts with a hammer until two neighbors were able to tie his hands.

In October, Furey Ellis was elected chairman of Byberry's board of trustees, replacing Louis Spring. Ellis owned a real-estate company—Furey Ellis Inc.—and was a member of several other hospital boards. In January 1948, a renovation plan for the West Group was developed. Pepper and others worked on the improvements, starting with C-9 and C-11. According to Sielke, "We'll tear out old flooring, rotting beams, broken plumbing and weakened steam pipes until about the only thing left will be the outside walls."

## Fabulous Fifties

The decade from the close of the war to the mid-1950s was Byberry's vacation period. The hospital ran just as good as any other—and better than some. The GSA was pouring millions into its expansive building plan, and the public was kept aware of its progress through large building dedication

Examining brain tissue in N-3 laboratory, circa 1952. *Pennsylvania State Archives, RG-23.*

ceremonies and positive publicity. The new buildings all featured up-to-date facilities that were on par with, if not superior to that of, any other modern institution. Although still understaffed and overcrowded, the new buildings did more to help Byberry's patients than anything else in its history. The hospital had the highest number of staff it ever would and was actually considered a modern hospital.

Groundbreaking for N-3. *Left to right:* Frank W. Mark (construction firm), George W. Pepper Jr. (architect), Furey Ellis and Dr. Eugene Sielke, 1947. *Temple University Urban Archives.*

The vital maximum security building for males, building N-9, opened in 1949. Its layout featured two enclosed courtyards and two large patient dining rooms with kitchens, one on each floor. The wards were designed on the latest recommendations of dignified mental health professionals. They were made up of dormitories and day rooms that featured four-foot-high walls separating the sleeping quarters. From the nurses' stations at the ends of the wards, they could observe the entire ward over the four-foot partitions. The front of the building featured visitation cubicles and the administrative offices.

Since 1947, Byberry officials had been pushing for a treatment building. The term "treatment" simply referred to a building built in such a way that it provided more for its inhabitants than custodial care, a building designed with patient luxury and rehabilitation in mind. Finally showing signs of having learned from the past, officials requested a building that "cured" patients and released them, rather than housing them until death. Furey Ellis fought hard for the new building, which he called a "hospital within a hospital" and an "active treatment headquarters." He managed to get half of the funding with an agreement by the state to provide the rest. In September 1947, Ellis himself broke ground for the new $2.5 million "Active Therapy Building," N-3. "The members of the board of trustees of the Philadelphia State Hospital expressed gratitude that the building program at Byberry is about to get underway," Ellis said, "and the members are delighted to learn that the Governor has allocated this $8 million dollars to mental institutions. However, we hope that the House of Representatives and the Senate give us the thirty million we requested as the absolute minimum for the next biennium."

N-3, the showcase of the state's building plan, was dedicated in May 1950. The new building—Byberry's tallest—was also probably the most important. As noted in its title, the active therapy building was the only building at the institution that was designed for the sole purpose of treatment, rather than simple housing. The four-story building had room for 250 patients, 125 of each gender. Located near the front of the property, next to the west (now central) group, its layout was rather simple. It was made up of one main corridor, which ran northeast to southwest, with two smaller wings protruding from the main corridor. The east wing housed patients who were selected for participation in treatment. Following the methods for dormitory construction introduced in building N-9, centrally located nurses' stations provided staff with a clear view of each ward across four-foot partitions separating the patient sleeping areas. It also featured outdoor porches connected to the day rooms, activity rooms and brighter dormitory areas. Even the seclusion rooms were slightly larger and provided great views from their windows.

Governor James Duff sets cornerstone of N-3, 1950. *Pennsylvania State Archives, RG-23.*

The west wing was the "therapy wing." It was only for staff and consisted of laboratories, testing equipment, a pathology department, treatment rooms, a library of medical textbooks and specimens and a 110-seat auditorium for staff lectures and presentations. The building would use student doctors and chemists to experiment with new drugs and other types of experimental therapy. On the roof there was a small "emergency laboratory," which was a precautionary step. In the event that a developed drug caused too many patient deaths, further testing of the substance would take place on animals in the emergency lab. The basement of the west wing housed the pathology department. The large autopsy room featured stadium seating for medical students and a locker room. The adjacent mortuary contained a morgue with a capacity for ten. A progressive concept was certainly in place with the opening of N-3.

The Philadelphia-based company Smithkline/French (SF) became rather heavily involved with N-3, using the building as a training school for its employees. N-3's labs, combined with Byberry's patients, provided a ripe testing ground for new drugs. The company was one of a few who contributed to Ellis's half of the financing and was therefore granted the right to use it. The company's work in the building contributed heavily to the development of its wonder drug Thorazine. It was tests on Byberry patients in N-3 that allowed SF to perfect the drug. Ground was broken for S-2 building in 1947. It was a clone and neighbor of S-1 and had a designated capacity of 450. It opened a year later, at a cost of about $2 million. In December, building A (E-2)—the "Rose Garden"—completed its amazing renovation at a cost of $850,000. New shower rooms, day rooms and dormitories made it, as Sielke called it, one of the best buildings in the institution.

After two years of construction, the new tuberculosis hospital, building N-10, opened in 1952. This sprawling structure was 540 by 300 feet in area, Byberry's largest building. It was very modern and featured every conceivable amenity of a tubercular hospital. It had a capacity for three hundred, with

Autopsy theater in N-3, 1950. *Pennsylvania State Archives, RG-23.*

male patients on one side and female patients on the other. It contained two enclosed and two open-ended courtyards for patient recreation. Tubercular patients had to be segregated from the population, and the new building was self-sustaining from the rest of the hospital. It contained three elevators, two cafeterias with modern kitchens and dishwashing facilities and a medical wing with dental, laboratory and X-Ray apparatus. Since tuberculosis was spread through clothing and other surfaces, staff were required to shower and put their clothes through the large autoclave sterilizer before leaving the building. Spacious showers and changing rooms were provided, and each staff member was given a locker, hundreds of which lined the building's hallways, lending it the appearance of a high school. The basement contained a new pharmacy, an incinerator for soiled linens and two immense underground recreation areas built beneath the courtyards and rear wings.

Following N-10 was N-8, a building for "over-active females," which was dedicated in 1952. Its layout copied that of its counterpart, N-9. This building, designed by Lichty and Stopper, featured rooms with heated floors for patients who refused to wear clothes. The GSA's plan required a new group of utility

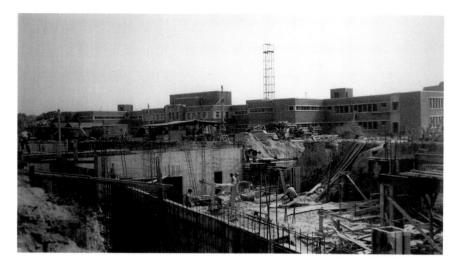

Construction of N-10, showing foundation of basement recreation area, 1950. *Pennsylvania State Archives, RG-23.*

buildings to keep up with the small city's growing needs. Located south of Southampton Road and west of the power plant, this group included a laundry, a warehouse and two vehicle storage buildings. The garages were capable of housing fifty vehicles. The new hi-tech laundry building opened in 1953. It was one of the largest institutional laundry facilities in the country, contained 75,000 square feet of space and was able to process 800,000 pounds of laundry a month. It featured $700,000 worth of modern equipment, such as its unique pneumatic delivery system. Using only air pressure, the pneumatic conveyor pushed the damp laundry through metal ducts to the irons and presses. It was capable of moving the clothes across the building at speeds of up to sixty miles per hour. The building also featured a section containing two dozen sewing machines and other equipment for clothing, mattress and linen repair.

The new warehouse completed the utility group in 1954. With 250,000 cubic feet of space, it was large enough to accommodate the supplies that a hospital of six thousand patients required. Its refrigerated storage area contained 100,000 cubic feet and could hold a massive food supply. A new stretch of the power plant's railroad siding connected the warehouse to the New York Short Line, and its intercom system was very futuristic at the time. The Ergo-Therapy department placed patients into jobs of all sorts around the institution, and the utility buildings employed almost five hundred.

In June 1954, Dr. Sielke announced the interior remodeling of four buildings on the East Group, beginning with E-4 and E-5 (buildings E and

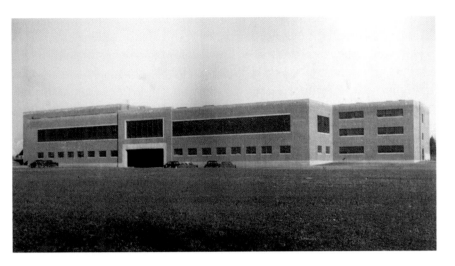

Laundry building, 1954. *Pennsylvania State Archives, RG-23.*

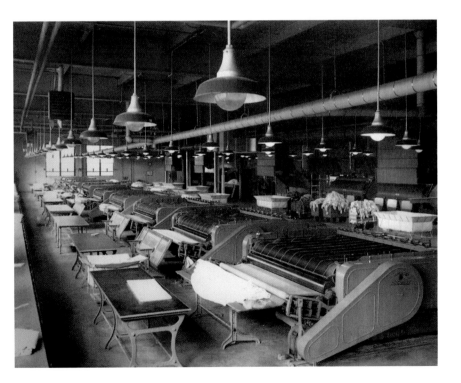

Pressing floor of laundry building. *Pennsylvania State Archives, RG-23.*

F). Sielke explained that "the old buildings consist of one main floor and a second-story rise in the middle of each, consisting of a few rooms. They were constructed as one large dormitory and day room." He described the plans to cut up the large wings of the buildings, adding partitions and creating separate rooms. "We have found this arrangement better in caring for our patients," he said. "The large, armory-type atmosphere of the old buildings had a depressing effect on patients." The work was completed in a year, and two more buildings on the East Group were remodeled.

On the night of November 4, 1954, Coroner Joseph Ominsky received his fifth elderly male patient from Byberry in six months. He claimed the autopsy of Max Kramon revealed internal brain hemorrhaging, but the cause of death was listed as "coronary thrombosis." Kramon, seventy-three, was found on the floor with a swollen lip; a bruised eye, nose and forehead; and cuts on his scalp. In seemed like strange deja vu at the coroner's office, and another investigation began into Byberry. "There are at least four other deaths at the hospital, which have not been explained to our satisfaction," blasted Ominsky, "and we want

Dedication of N-10 building, 1952. *Pennsylvania State Archives, RG-23.*

to know what actually happened." The hospital's response was that Kramon actually fell, causing his death. It was learned that the men were housed in building B because they had exhibited violent behavior. Dr. Sielke organized a regrouping of patients, and the elderly were no longer placed in the violent ward.

## Religion at Byberry

After being told to "hold on" several times and patiently doing so, advocates for better religious services for patients were finally satisfied when bids were accepted for a new chapel and auditorium building. In 1955, the GSA approved $684,746 for the building, which included a pipe organ, a chapel, two full-sized thirty-five-millimeter projectors for movies and a seating capacity of 1,200. But by the time it opened in 1957, the cost had increased to over $1 million. The GSA, along with members of Department of Welfare and hospital staff, decided to name the building after Furey Ellis, for his eleven years of "devoted service" as board chairman. The building's architects, Nolen and Swinburne, placed a plaque of Ellis in the ultra-modern lobby. At the building's dedication in May 1957, Ellis was eulogized by a host of characters, including new Welfare Secretary Harry Shapiro, Dr. Earl Bond and Dr. Sielke. He was presented with floral arrangements and cards. The building was connected to the West Group via an extension of the north connecting hall.

Religious services improved further at Byberry when it was decided to use one of the empty cottages off the children's group (PIFM) as a chapel for patients. The location would provide a quiet environment at a distance from other buildings. In June 1960, the Society of St. Vincent de Paul donated a life-sized statue of Christ, which was placed in a shrine outside the cottage. In December 1961, hospital Rabbi Abraham Novitsky and trustee Samuel M. Feldman enlisted the help of local businessmen, congregations and private donations from the Jewish community to rehabilitate another of the unused cottages into a synagogue for the hospital's seven hundred Jewish patients. The new synagogue in cottage 3 was dedicated on December 7, 1961. It was the first facility for Jewish patients at any state hospital in Pennsylvania.

Other faiths soon followed and redeveloped the remaining cottages into chapels. One became a Protestant chapel, and two others were converted into Catholic chapels, one for male and one for female patients. In 1965, the last remaining cottage was converted into a new Catholic chapel named

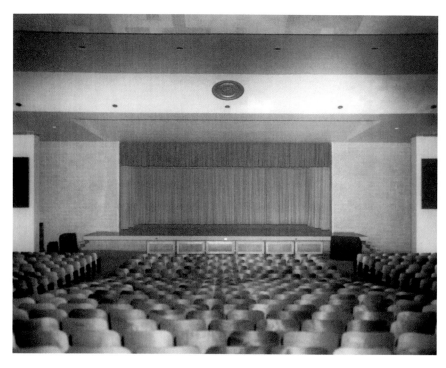

New Furey Ellis Auditorium, 1958. *Pennsylvania State Archives, RG-23.*

Bus in front of cottage chapel, circa 1965. *Pennsylvania State Archives, RG-23.*

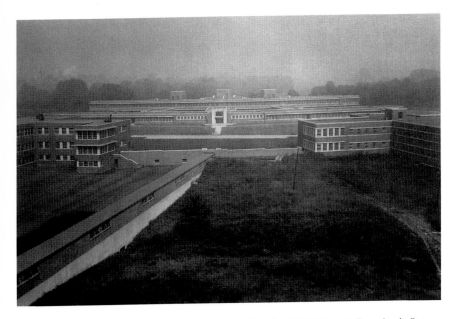

View showing connecting corridor. N-8 (left), N-9 (right) and N-10 (rear). *Pennsylvania State Archives, RG-23.*

for the patron saint of the mentally ill, St. Dymphna. Its first full-time chaplain, Reverend Richard J. Fleming, said that the addition of the chapel, completing the chapel group, provided Byberry with one of the largest and most complete religious programs of any hospital in the state.

## HOLES IN THE BOAT

By 1962, Byberry's problems had begun to float up to the surface. The hospital contained 6,300 patients, about 400 of whom were court-ordered, or forensic patients. Since Byberry contained two "maximum security" buildings, the state used them to house dangerous criminals (often murderers), as they had for decades in building B. The difference now was made by new human rights laws, which called, ironically, for proper treatment of prison inmates. Once tried for murder, if found guilty by reason of insanity—no matter how heinous the crime—the law required that an inmate serve his sentence at a hospital, not a prison. Byberry being the only forensic hospital in southeastern Pennsylvania, it naturally bore more of a load than was technically required.

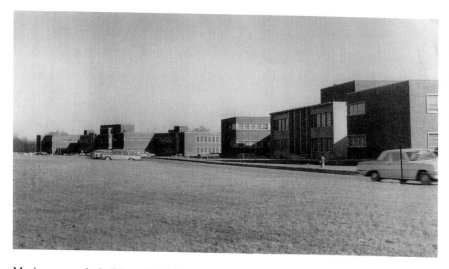

Maximum security buildings, N-9 (left) and N-8 (right), 1967. *Temple University Urban Archives.*

The maximum-security buildings, or buildings for "over-active patients," were N-8 and N-9. Built solidly under the auspices of top mental health officials a little over a decade before, these buildings were plainly showing that they were not very "maximum" at all. The windows were protected by thick screens that were meant to prevent escapes, but in the span of two weeks in April 1962, at least eleven patients escaped through the screens. Commenting on the escapes, Dr. Sielke said, "Until recently, we haven't had to cope much with this type of case. The average mental patient is pretty much individualistic. He doesn't plan for a group. If he escapes, he does so by himself. But the psychopaths, some of them, are very intelligent. They plan well. When they escape they take a whole bunch of fellows. It's almost like a prison break." Sielke asked for the construction of a new "escape-proof" building, or the renovation of an existing building, for this type of case. He stressed that unless the law was changed, Byberry would need financial help to improve the situation. "We are trying to combine a prison and hospital, and these are incompatible," he said. "We oughtn't to be in this predicament. From the standpoint of a hospital, these patients are difficult. They don't respond to tranquilizer or psychotherapy. They are intelligent and clever and can lead other patients astray. We are not physically equipped to control them." The GSA acknowledged the dilemma, but nothing would be done until the placement of the forensic unit twenty-three years later. The slope that Byberry teetered on the edge of was a steep one. When it fell, it would take a long time to hit the bottom.

# THE NEW APPROACH

## *Deinstitutionalization at Byberry*

### DOWNSIZING BEGINS

By 1963, President John F. Kennedy had succeeded in pressing for public awareness of the flaws in the American mental healthcare system, allegedly due to the commitment and lobotomization of his sister and the painful effects on the family as a result. Congress passed the Community Mental Health Centers Act, allowing each state to build many small health centers for the treatment of a smaller number of patients, as opposed to treating a larger number in fewer, much larger facilities like Byberry. It also called for separate centers for the mentally retarded, who until now had been housed in state hospitals among insane patients. Byberry became showcased nationwide as an example of this policy. How Philadelphia would deal with its longtime public health disaster piqued everyone's curiosity, but until the late 1960s, it was just talk. While Kennedy's concept of "de-institutionalization" gradually began emptying America's mental hospitals, its effects were different in every state. Pennsylvania proved to be a state in which deinstitutionalization was not overwhelmingly popular. A year later, the Pennsylvania legislature passed the Mental Health/Mental Retardation Act, which set up each county, broken down into districts, with a number of community health centers based on population. In Philadelphia, the city as a county, was divided into thirteen BSUs (Base Service Units). It was naturally the most populous county in the state and proved to be the most difficult to manage.

Dr. Frank Hasselbacher, state director of mental health, arrived at Byberry for a surprise tour in February 1965, accompanied by *Inquirer* staff writer Ralph K. Bennett. The two men were greeted by Dr. Sielke, who had no problem showing the men around the institution. In the East Group, Sielke noted building A's transformation and contrasted it to building D, which had not been renovated. When touring the north group, Sielke explained the abundance of geriatric patients. "There are about three hundred mental patients here who really don't have mental disorders, who could be taken care of in any nursing home," Sielke said. "But they are old, some of their families don't want them or they can't keep up payments on a private nursing home, so this is the place of last resort. We can't turn them away."

An elderly man approached the men, apparently having overheard them. "I've been here thirty-two years," he said. "I was kidnapped, and I've been here thirty-two years." The tour moved on to the women's geriatric ward, where the men were approached by another patient. An elderly woman, sobbing, walked up to the men. "Thank the good lord you've come," she gasped. "I want to go home to my mother." Sielke informed Hasselbacher that the woman was seventy-seven years old and probably was suffering from dementia. "Good care is all we can give many of them," said Hasselbacher. "But good care is not bars or walls, its supervision—people."

In November 1965, Dr. Sielke, with as little publicity as possible, submitted his resignation after almost twenty-five years at the hospital, nineteen of which he served as the superintendent. State mental health commissioner Dr. William Camp reported Sielke's decision to newspapers. "He had deep feelings for the hospital," Camp said. "He told me he was tired and felt it was time he gave it up. He didn't want a lot of fanfare." Sielke was known throughout the community as a caring doctor who never gave up on Byberry. His years at the hospital were testament to his dedication.

Upon his retirement, however, State Auditor General Grace Sloan attacked the condition of the hospital and Sielke himself. Sloan claimed that Sielke used the hospital's security detail as personal servants. "The security force is, to some degree, not more than a delivery service for certain hospital officials," she said. Sloan charged that in the first two weeks of September, "there were 20 entries indicating that a security guard delivered butchered bones to Dr. Sielke's residence for his dog." The level of escapes had increased, she said, because of Sielke's "misuse" of hospital personnel. "From January 1st to August 22nd, 1965, records of the hospital indicate there were a total of 337 patient escapes," Sloan said.

By December, almost 40 percent of the court-ordered patients housed in the maximum security wards in N-8 and N-9 had escaped. In a move to clean up the situation before neighborhood residents got wind of it, welfare secretary Arlin Adams urged another investigation. The Northeast Chamber of Commerce subcommittee chairman Albert Redles, in a letter to Adams, wrote, "Inmates are still escaping, and as you and I know, in all probability they never should have been committed to the institution. Nevertheless, they and others are in the Byberry buildings, and the state's responsibility, I feel, is to keep them there until a decision concerning their cases have been rendered." Adams asked for an appropriation of $450,000 to modernize the second floors of the two buildings into a more secure environment able to house violent criminals. His request, too, was ignored. Meanwhile, the state announced that it was choosing from three candidates to fill Sielke's position. It soon narrowed in on one: former president of the American Psychiatric Association Dr. Daniel Blain.

## Dr. Blain's Progressive Hospital

In October 1966, when Dr. Daniel Blain climbed into the saddle as the new superintendent, he was certain that political influence still weighed on the patients, and he had a new attitude on how to fix Byberry. Blain was internationally known for his non-intrusive approach to psychiatry and would prove to be one of Byberry's best administrators. He was born in China while his parents were serving as Presbyterian missionaries there. He was a graduate of Vanderbilt University School of Medicine, served with the U.S. Public Health Service during the war and later was a professor at the University of Pennsylvania. After Blain's first one hundred days at Byberry, State Mental Health Commissioner William Camp sang his praises, stating he survived "one of the most difficult jobs in the world."

As a Philadelphian, Blain was well aware of Byberry's horrific past, and as a superintendent, he sympathized with his predecessors' "frustrated and discouraged" circumstances. He had heard about Byberry's situation since his childhood and knew it as "the wastebasket of the city." Now it was the largest mental hospital in the state, and he was at its helm. Though he admitted from the start of his position as superintendent that if Byberry's operation was not drastically improved, "the level of psychiatric care in this city will suffer proportionally," Blain was up to the challenge.

Franklin Clarke (left) presents Daniel Blain with a plaque. *Pennsylvania State Archives, RG-23.*

One of Blain's biggest challenges, he said, was the deterioration of the physical plant itself. The East Group was unusable except for a few buildings. "Some sort of crisis seems to arise three or four times every day," he said. In the West Group, two buildings' heating fans seized, resulting in the removal of patients into the hallway, where the chill was "less biting." As a condition of Blain's acceptance of the position, and at his personal insistence, his friend and colleague Dr. Franklin R. Clarke was brought onboard as assistant superintendent. Commenting on the population, which was 5,800 when he took the position, Blain said, "I still have some hope that we can reduce the rolls by 1,000 in my first year," a goal he would achieve.

During his time in charge, Blain oversaw the transfer of 90 percent of the hospital's male patients from the decaying buildings of the East Group to the two large workers' buildings, S-1 and S-2, and the discharge of the other 10 percent. While it may seem a step backward to cram almost 2,500 patients into two buildings, the new environment was like the Hilton compared to the E buildings. Governor Raymond P. Schafer, however, after visiting the men in S-1 and S-2, recommended the buildings be closed due to their physical

condition while offering up no solution. This clearly frustrated Blain, who was putting everything he had into Byberry and making real progress. His goal was to bring the population down to 3,000.

One of his notable achievements was the long-overdue release of patient Catherine Yasinchuk. Yasinchuk's story was truly remarkable. She was a Ukrainian immigrant who had come to Philadelphia at a very young age. In 1921, police had found her on the street "babbling." After briefly questioning Catherine and getting no apparent response, they took her for a psychiatric evaluation, and she wound up in Byberry. Catherine was a quiet, well-mannered patient at Byberry until 1968 when Blain, following blurry records on her, tried communicating in several different languages. When finally, a nurse began speaking to Catherine in her native Ukrainian, her eyes lit up and she began relating her story to the nurse. The seventy-year-old patient told of her journey to America at the dawn of the First World War and her desperate experiences here. Coming to the country alone out of fear, speaking no English, she found life in the city crippling. She told of a man she had once loved in her early life, the child she had with him and both of their apparent deaths. This is the event, she said, that pushed her crying into the arms of police. Yasinchuk was released to a nursing facility, under the care of the translating nurse's daughter, in 1969. She died in 1983.

While on a tour of the hospital in 1967, Bucks County State Representatives Milton Berkes and James Gallagher voiced thoughts of a new state investigation. During their tour, led by Dr. Blain, who had forgotten his keys he recalled, they visited S-1 building, which employees had officially labeled "the snake pit." It was "representative of Byberry's worst conditions," said Blain. As they approached the building, Gallagher called attention to the prevalent odor.

"It's the stench that first gets to you," Blain said, describing the ward. "The smell is in the walls and floors, and you can never get it out." He led the representatives up the entrance stairwell and, in an attempt to get the attention of a nurse, knocked on a window. A man approached the window from the inside. "Would you look for the nurse?" Blain asked loudly. "Will you tell the nurse that someone is here?" The man studied Blain for a few seconds, as if trying to solve a puzzle. "My name's Charlie!" the man finally replied and then quickly disappeared back into the sea of noise inside.

After finally gaining access to the snake pit, the men noticed the strong increase in foul odors. They saw hundreds of men in one dayroom, some just laying on benches staring at the ceiling while others tried to hide their faces with their shirts. Blain went on to explain that Byberry was the largest

Boy Scouts plant trees in front of S-1, the "snake pit," circa 1965. *Pennsylvania State Archives, RG-23.*

mental hospital in the state, but it received the least amount of funding per patient. "We get $8.20 per patient each day, which is up from $5.17 a day last year," he said. "Haverford State Hospital gets $21.00, and Eastern State School and Hospital up the boulevard in Trevose gets $30.00 to $35.00 a day. I don't know why it is. Ask the governor." They did, and Governor Schaffer opened his own investigation. He inspected the hospital personally and ordered several buildings closed, starting with the snake pit. After shifting the elderly patients from W-7 to W-6, minor refurbishments were made to W-7, and it became designated "South Unit." Its connection to the traffic tunnel was bricked up, and a razor-wire fence was erected around the third-floor porch in preparation to receive the violent males from S-1 and S-2. S-1's 550 male patients were moved there by June 1968, and the building was condemned by the state and sealed up. In August, S-2's last 150 patients were moved to W-7, and the twin "snake pits" began their term of vacancy, boarded and locked.

Several attacks on employees by patients that occurred on the grounds of the hospital after dark demanded a call for streetlights. The buildings had exterior perimeter lights, but the majority of the grounds were unlit, including the roads. When a female employee was assaulted and raped returning to her ward after dark to retrieve her purse, the state made lighting

a priority. In February 1968, $250,000 was appropriated for a lighting program, and the Philadelphia Electric Company installed 286 mercury-vapor lamps mounted on stainless-steel poles throughout the property.

## CAMP WONDERLAND

In October 1967, as part of Blain's new therapy system, a tract of ninety-two acres in Buckingham Township, Bucks County was purchased by the state for use by Byberry patients. Located at Holicong and Ashmill Roads, the former Wonderland Day Camp, according to Blain, would provide an incalculable relief to patients who had been cramped up in their wards. The camp was ideally suited for the hospital's purpose. It contained twenty-two buildings, with a dining hall and an outdoor amphitheater. It also featured a swimming pool, a lake and several ball fields. The camp's new director, Malcolm Winkler, spoke excitedly about it. "Pennsylvania is the first state to have a permanent mental health camp, and we want this to be a success," he said.

But the community did not share Winkler's progressive outlook. They had not even been told of the state's plan and expressed outrage and concern for their very rural community. A civic meeting was held in November at the Midway Fire Hall in Lahaska, where residents voiced their fears about the camp. They claimed that the patients would present a serious danger to children attending a new school that was under construction at the time. Some residents were in favor of the camp and welcomed its presence in the community, but even they were angered that neither the state nor the hospital gave them any notice of their plan.

"Attorneys for the estate with whom we've been negotiating asked us not to publicize the fact that we were acquiring Wonderland Camp," said Blain. "I'm afraid the people in Buckingham who oppose the camp lack an understanding of what we are doing and hope to do there in the future."

Dr. Blain fully assured the citizens of Buckingham that the patients at the camp were harmless and posed no threat to their community. "All the patients chosen to attend the camp are carefully screened from patients who have ground privileges at the hospital," he said. "These patients are not dangerous. We opened the camp to take them away from the hospital and let them see something of nature and get a little color in their cheeks."

Winkler, who lived at the camp with his wife and young children, stood behind Blain on the issue, stating, "If I thought for one minute that my wife and children were in danger, I wouldn't be here. What we are doing is taking people who will be released shortly and trying to hasten their cure by letting them come in contact with nature."

The patients' contact with nature was short-lived, however, as the overwhelming opinion of Buckingham residents was that the camp had to go. By November, two patients had already walked off the grounds of the camp. Their whereabouts were not discovered, and while Blain called the two patients "harmless," nearby residents were frantic and doubled their efforts to get rid of the camp. In December, the Buckingham Taxpayers Association threatened to involve state officials. Its president, Roger Williams Jr., exclaimed, "If almost immediate action is not taken by the commonwealth to cease operations at Wonderland Camp, the association intends to take action in the courts to stop the operation, and stop it right now." Blain finally succumbed to their pressures and closed the camp down.

Female patients paint a mural in N-6, circa 1969. *Pennsylvania State Archives, RG-23.*

But in April 1968, he renewed the three-year lease of the camp. The hospital was paying $2,000 a month for the ground and was determined to make full use of the property. Thirty-five female patients were bussed in and out of the camp daily. They spent six hours a day enjoying its facilities, under the close supervision of director Winkler, four attendants and a nurse. But again the Taxpayers' Association responded by forming a committee to "dig into this thing." Hospital records indicate, however, that the camp remained in use for another five years.

## Getting Real About Mental Retardation

Deinstitutionalization brought on awareness leading to a new attitude toward mental retardation and its segregation from mental illness. Byberry's inadequate unit for retarded patients in buildings C-4 and C-5 was growing in population as the system shifted more patients around. But relief was underway. In 1968, as part of the state's Mental Health/Mental Retardation Act, the Woodhaven Center was created. It seemed only natural that the state use land it already owned, rather than purchase new land for a site. The GSA decided on one hundred acres along Byberry's southern border, Woodhaven Road, east of Route 1, and ground was broken in August 1968. Dr. Donald Jolly, commissioner of mental retardation, explained Pennsylvania's new concept. "We are going to limit the individuals in each group so that we can do something in the way of training them," he said. "Instead of having sixty persons in one ward milling around aimlessly, we will keep the children in groups of twelve and adolescents and young adults in groups of sixteen."

The modern 280-bed facility, strictly for retarded patients, cost $11.3 million to build. It provided a charming transition for patients from Byberry. The seventeen buildings of the new institution were one-story brick structures. The Woodhaven Center was very modest in appearance, and the interiors were bright and cheery. It opened in 1971 and is still in use today, in cooperation with Temple University. It is considered one of the finest facilities in Philadelphia for the care of the mentally retarded.

## NEIGHBORHOOD RELATIONS

By 1970, the neighborhood of Somerton had grown into a flourishing, suburban community and was experiencing its own version of Buckingham's situation. The children who grew up in Somerton could not help but discover the state's largest mental hospital down the street from their homes. Most were strictly forbidden by their parents to go near the sprawling complex, which only made it more alluring. Some were naturally fascinated by it. Either way, their presence soon became a problem. Curious children who wandered onto the grounds or approached the buildings were often frightened away by patients. But in some cases, children mingling with patients led to obvious dangers. Patients who had ground parole would also wander into the neighborhood, and concerns were immediately voiced by Somerton residents.

The PSH Auxiliary, headed by Thelma Ribaut, started the "His and Her Shop" in the basement of W-3 building in 1969. Operating only through

*Left to right:* hospital business manager William Simone, SYO athletic director Alfred Operacz, clinical director James Miller and SYO president Walter McHugh, 1970. *Temple University Urban Archives.*

Opening of the "His and Her Shop." *Pennsylvania State Archives, RG-23.*

donations and volunteer help, the shop allowed patients to browse and purchase clothes in an effort to help familiarize them with the outside world. The auxiliary raised $3,000 to renovate the former occupational therapy room. "Being able to choose for himself, in a modern store-like atmosphere is something that some patients haven't done for years," said Ribaut. "Many may have even forgotten what a store looks like." The shop was open from 10:00 a.m. to noon and 1:00 to 3:00 p.m.

In July 1970, the Somerton Youth Organization, a nonprofit group founded in 1955, acquired eleven acres of former Byberry property for use as baseball fields. Entering into a contract with the State Department of Property and Supplies, the organization leased the land for one dollar per year. It contained three baseball fields south of Southampton Road and east of the New York Short Line and is still in use by the organization today. Alfred Operacz, the group's athletic director, reported that it had spent $1,700 to have the grass cut. He also praised the hospital, stating, "Relations with the hospital are fabulous. They give us every cooperation we ask."

Byberry's neighborly relations under Blain were one of its friendliest features. They were almost fractured however, on March 5, 1970, when a 180-pound, six-foot patient named Levi Graham was found living in one of the hospital's steam tunnels, below the unused South Group. A police dog

led authorities to Graham's location, where he had been living for months. Graham was found to be in possession of keys to several buildings, including the kitchen. He had accumulated six cases of orange juice, five boxes of crackers, thirty loaves of bread, a case of canned tuna, a half-case of peanut butter, a case of tomato purée, four boxes of oatmeal cookies, a pocket knife and, of course, a can opener. Graham offered no resistance and was charged with various counts of theft. The same year, two patients were found dead on the hospital grounds.

## THE RISE OF DR. CLARKE

By 1970, Dr. Blain, after some notable accomplishments, seemed to have lost his energetic fight to reform Byberry. It was said that he was seen less and less at the hospital. As an author, Blain published several books throughout his impressive career, one of which he wrote during his term at Byberry. His trusted assistant superintendent, Franklin R. Clarke, took on more and more of the responsibility for running the hospital. Whether Clarke was covering for Blain during his "authoring" is not known. However, Frank A. Salvatore,

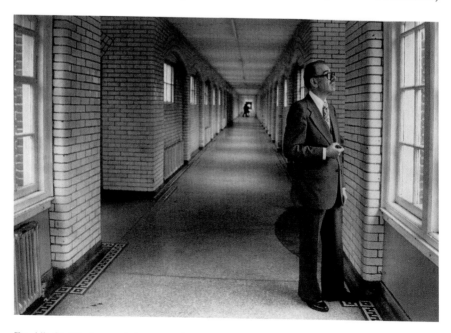

Franklin R. Clarke stands in connecting corridor, 1979. *Temple University Urban Archives.*

state representative from Byberry's ward, was not impressed by Blain's second career. "Dr. Blain spends his time writing books, using a state secretary and other personnel, and is unavailable at any time," Salvatore said. "According to published reports, he receives an annual salary of $30,540."

Salvatore's comments did not seem to bother the seventy-one year old. He had lost the ability to stay on top of Byberry and had begun to favor other interests. After discussing the matter with Clarke, who had been practically running the hospital anyway, Blain resigned. He remained on the payroll, however, as a part-time assistant director of research and education. He was probably Byberry's most efficient superintendent, and he knew it. During his administration, he cut Byberry's population by more than half, from 6,100 to 2,600. Fortunately, he maintained his reputation and received public praise for his work at Byberry. Clarke officially stepped into the superintendent position in January 1971. His first year as superintendent should have been a warning. He stepped in at a time when Byberry was disintegrating faster than ever before, due to its yearly drops in funding. Upon his appointment as administrator, several interesting events took place.

In 1971, staff psychiatrist Dr. Lois Farquharson would become the center of a sensational murder trial. While working at Byberry, Farquharson met twenty-eight-year-old Gloria Burnette, a fellow employee. The fifty-five-year-old Farquharson became infatuated with Burnette, and the two women became lovers. But at a time when gay rights was a very touchy subject, their relationship was not well received by their supervisors. Dr. Leon Weingrad, Farquharson's superior at Byberry, had voiced an opinion on the issue that led Farquharson to believe he was working on a way to dismiss her from her position. Fearing Weingrad was trying to keep the two apart, perhaps for other reasons, Farquharson talked Burnette into shooting Weingrad to death in the parking lot of her Society Hill Towers condominium. Both women were arrested, and a three-year trial followed.

Lynne Abraham, then an assistant district attorney, put the blame on Farquharson, calling her "the puppeteer...the string-puller." But Farquharson's attorney tried to paint Burnette as the evil manipulator. He said Farquharson had been "totally under the control of her lover, not the other way around." But in March 1974, Farquharson was found guilty of first-degree murder and sentenced to life in prison. She filed for several appeals of her conviction, but none were granted.

In October 1973, as part of the next step in downsizing, Dr. Clarke announced that the patient transfer from the East Group had been completed. He also reported the closing of the three cottage chapels in the south group

to save the $6,000 yearly heating cost. Representative Salvatore expressed his outrage at the decision. "It appears the department is more interested in protecting ghosts and political favorites at Byberry than in providing proper medical care and its necessary supporting facilities, or than in instituting sound business practices and inventory controls," he said. "It's not enough that they have stripped the patients of their dignity. Now they're going to remove a source of religious inspiration which frequently is the only comfort for many of these unfortunate people."

Clarke stayed positive. He pointed out, "It was only a few short years ago that patients were sleeping in basements, but this year there is only one occupied ward above the second floor in any building." He also stated that the hospital policy was changed to allow patients to wear their own clothes instead of hospital-issued garb. Clarke, at a staff meeting, credited employees for their work during the year. "The job freeze, which saw our employees drop from 2,287 to 1,915 through attrition, resignations, deaths and retirements, can be expected to continue through the year," he said, "while employees may look for another slight pay increase this year." The year 1973, according to Clarke, was "one of the most confused ever." A $3 million budget cut, the loss of 373 employees and the state's hiring ban would make 1974 "another trying, turbulent, tumultuous year."

The Wonderland camp had been on the chopping block for years when, in 1973, in response to more cuts in Byberry's yearly budget, Clarke discontinued its use. It was costing the hospital almost $17,000 a year. The announcement was made publicly, and the residents of Buckingham were notified. They were relieved to finally be rid of the "big city's" dirty mental camp. But two years later, like a haunting memento, the property's new owner discovered the skeleton of sixty-four-year-old patient Gordon Smith in a wooded area on the edge of the property. Smith had walked away from the camp sometime before 1973, staff said, when he was declared a "walk-off." Buckingham residents, in later years, would tell spook stories of the camp to children. It was Byberry's mark on their small town.

In June 1975, a maintenance worker in W-6 building discovered the body of Mary Ann McGrath in an exhaust vent in the building's roof penthouse. The body, in a "mummified state," was identified through dental records. Housing only mechanical apparatus, the area was always kept locked to patients. McGrath, thirty-two, had been missing for nine months. She had been a patient at Byberry since the age of thirteen.

## Ben Rush Park and the Bicentennial Boggle

As early as 1969, talk loomed among city officials as to how to use the upcoming bicentennial celebration as a way to bring money into the city. The two-hundred-year anniversary of the signing of the Declaration of Independence was an event that Philadelphia had been counting on to bring it out of its shaky financial status. Many historic landmarks were rehabilitated and turned into tourist attractions, and many new structures were built, such as Veteran's Stadium. With Byberry already downsizing, new land was available on portions of its 1,100 acres, and naturally, it became a point of interest to some as a possibility to be the site of the city's festivities. The transfer of patients and equipment from the East Group was nearing completion, and the buildings would soon be vacant. Some suggested the city rehabilitate those buildings for use in the event.

Meanwhile, local efforts to raise funds for the restoration of the almost three-hundred-year-old birthplace of Benjamin Rush appeared in the form of school projects, candy sales, car washes and donations. Advocates for the land inclusion in the "bicen" had good cause for an uproar. They charged that the city had fought against the Byberry location from the beginning, for reasons of its own. Local officials and residents had formed a committee to raise money to save the Rush House. They were excited about their plan to restore the house as part of a colonial-based theme in what they called "Benjamin Rush Park."

The city conveniently put an end to the debate however, when it "accidentally" demolished the house one night in 1969. Lawyer for the Rush House committee, Harold Rosenthal, accused the city of deliberately tearing the house down. The committee was able to save the debris from the house, however, and had it moved to the grounds of Byberry, with plans to reconstruct it. By 1972, after plans for the bicentennial had completely shifted from Byberry, the hospital was again in the dark. But the state continued to profit from sales of Byberry's land, and Rosenthal and others continued to push for a park on the grounds named for Benjamin Rush. They recruited twenty-eight other community groups and organizations to join their cause.

The sale and lease of land continued, and a plot of ninety acres bordering Roosevelt boulevard on the east side, south of Southampton Road, was leased to the National Guard for its new armory, which was erected in 1972 and is still in use today. But while the state profited, the city grew weary of the sale of its land and looked into a way to acquire it back. The property had been reduced to approximately six hundred acres and only about a

Groundbreaking of Rush House reconstruction. *Pennsylvania State Archives, RG-23.*

third of it was being used by the hospital. The legislature from 1938, which gave the state ownership of the property, stipulated that if the state did not continuously operate facilities on the land, it would revert back to the city. Bernard Meltzer, chairman of the City Planning Commission, spearheaded an effort to regain the land back for the city. "We feel the state is violating the agreement under which the land was given," Meltzer said.

The Philadelphia Chamber of Commerce led an effort to get the land purchased, pressing for industrial parks within the city boundaries to increase its tax base. State Representative Salvatore pushed for the park on a portion of the ground. "We live in an area where the density factor is so great we need some relief for the people," he said. "We've got wall-to-wall children." The idea of turning a portion of the land over for use as a park had been floating around for a few years, but few thought it would come to fruition.

As ideas for the land's use were thrown back and forth, its value was increasing. Although not confirmed, this could easily be seen as a way to raise profits by the state. It seemed that every interested party had a chance to bid on the property, and the city held up the process further by backing

local business interests. One proposal came during the closing of the Frankford Arsenal in 1974. The Rizzo administration offered up 150 acres of Byberry's land to Army Secretary Howard H. Callaway to build a new arsenal, thus saving over one thousand jobs. The trade would also bring jobs into the northeast. But Somerton and Parkwood residents opposed the idea. Another proposal was for a school for juveniles with criminal backgrounds. Needless to say, this, too, never materialized.

In 1975, the State Senate voted 48–0 in favor of the final agreement. In December, Governor Milton Shapp signed the bill transferring a total of 684 acres of land back to the city under the Byberry Land Transfer Program. This gave Benjamin Rush State Park its 275 acres, which included 170 acres of prison farm property. The remaining 409 acres was to be divided between commercial and light industrial buildings. One hundred acres was also set aside as a site for a new veterans' home. The state held onto the 300-acre plot east of Roosevelt Boulevard, between Southampton and Woodhaven Roads, as park advocates were pressing to include it as part of the park.

Philadelphia Probation Division supervisor Joseph R. Ruggiero, in a philanthropic effort, started the Self-Help Movement in 1968. Ruggiero had noted that many parolees he saw were drug users and that addiction was the root cause of the majority of his clients' criminal actions. With help from fellow common pleas court judges, Ruggiero acquired the vacant, three-story addition to the nurses' home on Southampton road for use as a rehabilitation center for sufferers of addiction. The state agreed to lease the dilapidated building to Ruggiero for $1 per year. Using only donated funds and resident labor, the group had fixed up the building by 1970. In 1976, Ruggiero acquired the rest of the building. Through fundraisers and generous nonprofit donations, the Self-Help group raised over $30,000.

In 1979, the Rizzo administration announced that the city had finally acquired the last remaining piece of Byberry's land. The three-hundred-acre plot west of Roosevelt Boulevard, between Byberry Creek and Woodhaven Road, was designated for use, as it is today, as the Hornig Road Industrial Park. The plot contained most of the South Group—the original PIFM cottage group and buildings S-1 and S-2. By 1980, these buildings were all demolished, and Hornig Road was in place. The new light-industrial buildings were in operation by 1983.

## THE FORENSIC UNIT

The more Byberry drained away its patients, the more flotsam and jetsam emerged near the muddy bottom. The population continued to drop, and the community realized that the hospital had been housing a number of court-ordered patients, most of whom had committed at least one murder and were considered insane. Needless to say, this did not go over well with the residents of Somerton. As more patients' records were examined, more violent patients were discovered, lost in the hospital's vast population. But although the hospital was required by law to house these types of patients, it was truly incapable, for obvious reasons, and the administration did everything it could to avoid these cases. If they were housed in Byberry's maximum-security wards, buildings N-8 and N-9, it was usually not for an extensive period. These cases usually either escaped or committed homicide at the hospital and were transferred out.

In some instances, psychiatrists would say whatever they needed to say, true or not, to keep a violent patient off Byberry's wards. One such case was that of Winifred Ransom, who was placed in Byberry in 1975 after her police confession. Ransom shot and killed Margaret Sweeney, who was about to give birth to a baby girl, in November 1974. She then performed a Caesarean section on Sweeney with a butcher knife and tried to abscond with the baby. The child survived and was given to relatives after Ransom's arrest. But after a twenty-month evaluation at Byberry, psychiatrists ruled that she was no longer insane, and Ransom was released on her own recognizance.

By 1980, some state officials were beginning to realize that after all the investigations, all the reappointments and staff reorganizations, after all the regrouping and restarting, Byberry was essentially no better than it was when the commonwealth first took charge. Others had known for years that no matter what changes in staff were made or how many investigations turned up deplorable practices at the hospital, conditions would never improve because corruption is what Byberry was built on. It was imbedded in the hospital's framework, both literally and figuratively, like a cancer. Many knew what needed to be done. The hospital needed to be closed—forever. But that seemed like an impossible task. Too many strong political nuts-and-bolts were holding Byberry in place. The easiest way out was to put the blame on an individual or group, usually the superintendent, and publicly hang Byberry's troubles on them before making them walk the plank.

On November 19, 1980, Department of Welfare deputy secretary Scott Nelson, passing on the responsibility, removed Franklin Clarke as

superintendent. Clarke was demoted to the rank of staff consultant, with a 10 percent cut in salary. "We were not pleased with Dr. Clarke's performance at the hospital," Nelson claimed. But it seemed obvious to employees and to Clarke himself that the real motive behind his dismissal was a financial one. Clarke said that when he was first asked to resign in October, he refused and alerted the hospital's board of trustees of Nelson's move. But before a hearing could be arranged, Clarke's demotion was announced by Governor Richard Thornburgh. The eight-member board stood behind Clarke, however, and all resigned over the issue. They claimed that their input was not sought or considered. The board's letter of resignation read, in part, "It would appear…that the power of recommendation of the board is virtually nonexistent. Changes in the administrative personnel of the hospital and of hospital policy have taken place without the opportunity of the board to provide input, and in fact, over the loud objections of the board."

Board chairman William Batoff truly sympathized with Clarke, who had claimed, perhaps a bit too loudly, that state salaries were far too "puny" to provide for a half-decent staff. Citing politics as usual, Batoff knew that Clarke's resignation was not by choice. "Don't tell me that Clarke agreed to step down. That's garbage," said Batoff. He also tried to explain that the state "won't change the hospital by removing him. You must change the system." But Nelson was all politics. He had no apparent desire to stop the board's resignation. "I think we will definitely press on without them," he said.

But by October 1981, the absence of a group of trustees was clearly showing. The hurried transfer of patients had brought Byberry's population

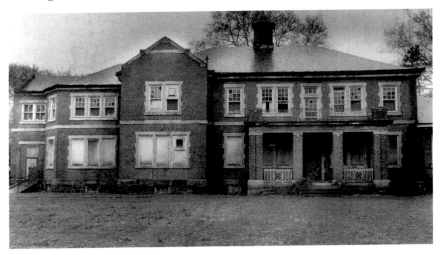

Unused C-6 building, 1982. *Temple University Urban Archives.*

down to 840 patients and showed no signs of slowing. Meanwhile, more buildings in the West Group were closed and shuttered. Roughly 60 to 70 patients a month were transferred to just about anywhere they would fit. Some were sent halfway across the state, making family visitations next to impossible. But civil rights attorneys were watching the process very closely, making it harder for Byberry to dump its problems. Patient advocate attorneys finally brought on a suit against the hospital for, among other civil rights violations, placing the patients and their new caregivers in danger. But district Judge James T. Giles ruled in favor of the hospital, and the transfers continued. A noted hospital highlight for the year was the first use of mace by a Philadelphia police officer. Sergeant Charles Smith used his newly issued mace to subdue an escaped patient, Lamar Odd.

## Staff Scramble

After the Clarke ordeal, Byberry was left without a superintendent or a full board of trustees. His position was filled by Dr. Earline Houston, who held the distinction of being the first African American graduate of the Medical College of the University of Tennessee, her home state, in 1967. Houston began the position in 1982 and immediately faced charges of mismanagement. The effects of deinstitutionalization on Byberry had lowered its status back down to hellish. It seemed, however, that only those who had close contact with Byberry—staff, hospital advocates and local officials—appeared to understand this. The administration was given no slack publicly for the unmanageable financial situation with which it was forced to cope. No other state hospital in the state downsized more than Byberry. Between 1966 and 1982, the hospital relocated 85 percent of its patients, dropping from a population of more than 6,000 to less than 750.

Shortly after the start of their operation, community mental health centers in Philadelphia, although proving functional and ultimately superior to the state hospital system, were overcrowded. The patients who were the most in need of care, however, were the ones who suffered the most as a result of the downsizing. In a number of cases, patients suffering from debilitating mental illnesses—such as schizophrenia or psychosis—who were released lasted only days before committing suicide. However, having dealt with this instance dozens of times already, the effects did not appear to cause any reprehension or hesitation, as the process only continued.

In February 1984, Superintendent Houston issued a memo to every ward, distinctly asking each to select ten patients from the ward suitable for discharge, and the patients were released, apparently without any examination or approval from any qualified staff. Instead, having been reportedly given only six hours to complete the list, the ward supervisors themselves chose the patients. They were instructed not to allow a patient's goals for discharge and whether they had been met to affect their decision. They transferred patients to state and county prisons across the commonwealth, and some were sent to wards that the state contracted for use in other hospitals like Mount Sinai, Hahnemann and Frankford. Some were sent to state schools or facilities for retarded patients, like the Eastern Pennsylvania Psychiatric Institute (EPPI) and the Eastern State School and Hospital. Still plenty of others were moved to nearby state hospitals like Haverford, Norristown and Embreeville.

But dozens and possibly hundreds of patients were released to "family members," who in some cases turned out to be friends or even landlords. Local businesses and nonprofit charity organizations raised money to rent and purchase houses and apartments for patients. They were sent to boardinghouses, church group homes and just about any place staff could find for them. This did not go unnoticed. In July 1984, staff psychiatrist John Moran brought on a lawsuit against the Byberry administrative staff, including Superintendent Houston and Welfare Secretary Walter H. Cohen, for knowingly discharging vulnerable patients to their fate on the streets of Philadelphia. He charged that it was a violation of their constitutional right to due process. It was not hard to see a motive behind the patient dumping. The hospital was soon facing an exam by the Joint Commission of the Accreditation of Hospitals that would determine its eligibility to remain a hospital that accepted Medicare. This was probably the first suit that called for the rights of post-institutionalized patients.

By December 1985, the residents of Somerton were growing wary of the forensic unit. They had learned that for ten years, dangerous criminals had been housed at Byberry. Given the frequency of escapes and the neighborhood's previous experiences with escaped inmates, serious doubts surfaced about the security of the unit, and rational fear abounded. It held forty patients who had been committed for reasons of insanity after being arrested for hideous crimes. Talk of placing Harrison "Marty" Graham at the forensic ward in N-8 building in 1987 may have been the straw that broke the camel's back. Graham was the partner of Gary Heidnik, whose disgusting story of the torture and cannibalization of captive women in

the basement of his north Philadelphia row home was the inspiration for the character "Buffalo Bill" in the film *Silence of the Lambs*. Police found six decomposing bodies in the basement of Graham's "death house," a skeleton on his roof and two other skulls in an abandoned neighboring house. Whether Graham actually did spend time at Byberry is not known.

State Welfare Secretary Walter H. Cohen applied to Mayor Wilson Goode in January 1986 for the removal of Byberry's forty forensic patients to Holmesburg or another city-operated facility. Goode supported the idea of transferring the forty patients to Holmesburg or the House of Detention in a reply to Cohen but in person said he did not support the move. Since both prison facilities were overcrowded and, ironically, Byberry was not, it was thought that the fewer inmates who were placed in crowded conditions, the better. The state had plans to take advantage of the space at Byberry by expanding the forensic unit to eighty beds. The city won the suit, and the forensic unit continued.

To make matters worse, in January 1986, the Pennsylvania Nurses' Association encouraged its members to strike all across the state. At Byberry, only eight out of thirty nurses reported for duty. Public Welfare officials claimed that the higher-paid staff would fill in the nursing duties and the care of the patients would not be affected. However, this is highly unlikely. The rate of pay for a nurse at Byberry was ten dollars per hour, and as one nurse put it, "I could make more in a supermarket." Every paper failed to print, however, that the Byberry administration did a notably good job in taking care of its own. It offered stress management seminars for employees and greeted the striking workers, providing refreshments and the use of its restrooms. But as the physical plant and the infrastructure within crumbled, it seemed nobody took Byberry seriously. It was all but closed down, most of its buildings without power, but there were still hundreds of patients living there, and they took it very seriously.

In April 1986, Superintendent Houston, battling with cancer, resigned from the position. Sadly, she died in June, at forty-one years of age. The position was then filled by Dr. C. Charles Erb, who remained for a little over a year and seemed less adept at the position. It seems '86 was a bad year at Byberry.

## THE BLUE RIBBON COMMITTEE

In May 1987, Governor Richard Thornburgh, acting on the allegations he had received of patient abuses, appointed what he called a "task force" to investigate. Known as the Blue Ribbon Committee, it was made up of

six physicians, two lawyers, three nurses, two mental health advocates, a former state hospital patient and other experts in the field, all chosen by the Thornburgh administration. The task force was headed by Harrisburg lawyer Jonathan Vipond. Thornburgh also appointed a second group consisting of state employees from other public hospitals with rankings of supervisor or higher. The two groups worked almost simultaneously at Byberry on a weekly basis. As a member of the second committee, Dr. Bryce Templeton was surprised to find the staff he interviewed to be in good spirits and well suited to their jobs. Under the heated conditions, the staff seemed to be handling the situation quite well. But the decision had already been made. Byberry was being measured for its coffin.

# THE END OF AN ERA

## *The Closure of PSH*

### GOING UNDER

Closing Byberry permanently was a true battle against evil. It was a long, grueling war that had casualties of its own. The figures who lead the way in this fight were real heroes. If they had not taken on the burden of this issue, there is little doubt that more painful chapters would have been added to Byberry's saga. The Coalition for the Responsible Closing of Philadelphia State Hospital was organized by a group of staff members and state and city officials who poured their hearts and souls into the welfare of the patients whose lives hung in the balance. It seemed after the other decision to close Byberry was reversed, this would be a harder battle than anyone realized. The knotted web of dishonesty and greed that built up at Byberry for almost eighty years did not prove easy to untangle. It would take serious efforts and long, uncomfortable hours of hard work to even get the required ears to listen to the patients' plight.

By the mid-1980s, Byberry contained 600 patients and 910 workers. The operating yearly budget was approximately $39 million. State officials, Byberry employees and third-party reformers were all ready to take drastic action. Their individual ideas for what measures should be taken differed, however. While supporters of the closure began to grow in size, so did a group adamantly opposed to it. As with any battle for civil rights in America, there were plenty who still held a negative attitude toward the mentally ill. Many people still thought that Byberry was the only way to protect the

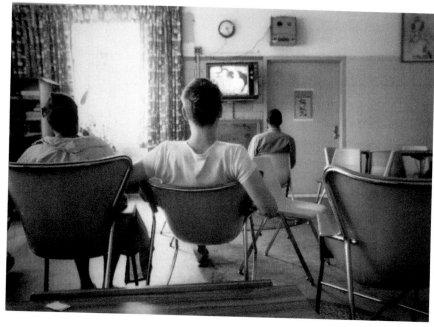

Day room, N-8, circa 1984. *Pennsylvania State Archives, RG-23.*

good citizens of Philadelphia from its "dangerous" mental patients. Of the hospital's 910 employees, 630 of them were represented by two different labor unions that were not about to let the loss of these jobs occur.

Representatives from the two unions announced that they would fight the Byberry closure every step of the way. Bernie Ellerkamp, secretary treasurer of Local 113 of the Pennsylvania Nurses' Association, who represented thirty of the hospital's forty-five nurses, said the association would "vigorously work to keep the hospital open." Edna Carroll, president of the American Federation of State, County and Municipal Employees Local 632, of which six hundred of Byberry's aides and attendants were members, also pledged to fight to keep the hospital open. These monied interests represented their members well. Unfortunately, the real victims at Byberry had far fewer willing to act on their behalf. The patients and advocacy leaders had little money to work with, unlike the unions, and the fight became more for the rights of the employees than the patients.

Looking to recruit more forces in the battle for closure, Welfare Secretary John F. White Jr. chose to seek outside help. He brought Martha Knisely on board as his mental health secretary. Knisely learned of the closure of a state hospital in Columbus, Ohio, just months before and the success with which

it occurred. A key figure in the success of its closing was Estelle Richman. Richman was a strong believer in community treatment teams. Her analogy of any successful mental healthcare facility was a "three-legged stool," made up of the three essentials: funding, properly trained staff and functional facilities. Byberry apparently met this criteria, but not to the necessary levels. Knisely recruited Richman to the cause, to the dismay of some staff. But ultimately, Richman would prove a crucial element in the closing.

By 1986, Byberry had become a dangerous environment for everyone, patients and staff. The hospital's infrastructure had deteriorated almost to pieces. Staff had dwindled to less than one hundred, but the patient load was nearing six hundred. Most of the unused buildings' utilities were shut off, and unsupervised patients had the run of the remaining campus. Truly a sinking ship, Byberry was shedding its doctors and psychiatrists much faster than its patients. The buildings were, in a way, war zones. The situation in the three buildings that remained in use became increasingly chaotic as the inmates, some still forensics, were under almost no control at all. Dangerous patients were shackled to their beds, but many were freed by other wandering patients. It was justly comparable to a horror film scenario.

## Casey Takes Up the Cause

Robert Patrick Casey was elected governor of Pennsylvania on his fourth attempt in 1987. He had been a state senator and served as auditor general of Pennsylvania. As a Democrat, his pro-life attitude was a notable tag of his campaign, as was his pro-gun stance. But he may not have done anything more important or humanitarian than undertaking the cause of Byberry's patients. He deserves serious praise for this act, for it was not the popular thing to do and he certainly made a number of political enemies as a result. Casey proved himself more than a worthy governor, thankfully, after having ran three other times. Casey had his work cut out for him, however. Upon assuming the office, the Byberry issue was one of the first he dealt with. On his second day as governor, Republican State Treasurer "Bud" Dwyer, whom Casey had lost to when running for that position, committed suicide on national television at a press conference preceding his allotted prison sentence for accepting bribes. Casey was impeccable in his multitasking of several startling issues facing the state upon his appointment. Perhaps he was still full of adrenaline from his

campaign race. For whatever reason, Casey shined, and for the first time in fifty years, patients' rights advocates had real hope.

The Blue Ribbon committee released its report in September 1987, and the results were certainly damning. It showed an emotional portrait of what amounted, figuratively, to a torture chamber with a tiny but luxurious lounge section. Most of the patients who were conscious enough to give their opinion to investigators expressed negative feedback about their care. The ones who weren't were either drugged or in seclusion. The results of the report, although negative, were said to have been achieved only due to another maneuver by the staff of temporarily releasing patients just prior to the committee's arrival and then supposedly bringing them back when they were gone. The staff, in turn, charged the state with using the committee as a way to shut the hospital down. The committee's report, they said, would say anything the state wanted it to say. It did seem, in a way, that Casey had his mind made up long before setting foot in the governor's office. The hideous report that he received just days after taking office was not hard to respond to. He acted on it quickly, and his desire for the closure was voiced almost immediately.

In September, State Secretary of Welfare John F. White Jr. announced that the end was finally near for Byberry. Speaking to the press from the hospital grounds, he said that the hospital would be completely shut down in twelve to eighteen months. Many of the employees interviewed were found to be sincere in caring about their patients and were clearly hoping against the closure. One could argue that they were fighting for their jobs, but it is the opinion of the author that the welfare of the patients, in most cases, was their true priority. Upon White's announcement of the closure, many of the employees felt almost betrayed. They had spoken highly of Byberry and the dedication they had for its well being, and after positive conversations with committee members and assurances that their opinions would be considered, many employees were confused. But during the brewing of battle, neither the staff nor the state would prove capable of controlling the ever-mounting chaos that continued to erupt out of Byberry's wards. Superintendent C. Charles Erb, having agreed to fill the position only until his retirement on January 1, 1987, was counting the days.

Upon the release of the Blue Ribbon report, Secretary White took immediate action. Three assistant superintendents and the clinical director were suspended for sixty days. Twelve attendants were investigated for abuse by White and his staff. Of these, four were fired, three were moved into positions not involving patient contact, one was transferred to Norristown

and two resigned. C. Charles Erb was allowed to continue with his planned retirement and was not held responsible for Byberry's conditions.

White was able to scramble together a team of professionals to hold the place together for two years until its scheduled closure. Filling the new superintendent position in September 1987 was Dr. Ford Thompson, of Harrisburg State Hospital. His assistant superintendent was Dr. Norman Flaherty, of Mayview State Hospital in Bridgeville. Thompson agreed only to hold (or bear) the position for one year, after which Flaherty would take over. Thompson was a respected psychologist and deserves proper credit for running both hospitals, Byberry and Harrisburg, simultaneously for over a year. When Thompson took over in the immediate aftermath of the explosive report, he said he'd been selected to clean up the "trash" at Byberry. He called attention to the horrific plague of abuse at his new hospital. "Early in September, and into October, we were averaging one new (abuse) allegation per day," he reported. But by November, the rate had dropped significantly.

On December 7, 1987, Casey formally announced that the closure would take place over the course of two years. The remaining 530 patients would be transferred to an array of other locations, including nursing homes, community centers and other state hospitals. "Last spring we created a Blue Ribbon Task Force to find out just how bad the situation was," Casey said via telephone press conference. "By September, we understood that it was every bit as bad—and perhaps even worse—than we had feared."

## Byberry Martyrs

Figuratively speaking, the soul of whatever made Byberry so primordially sadistic was beginning to feel backed into a corner. It was hitting back hard with acts of morbid cruelty, straight from the heart of evil itself. As the administration fought with officials and advocates over the validity of the report, consecutively more horrific stories reached the surface. One such story was that of Anna Caroline Jennings, whose unfortunate experience in Byberry seemed to help exorcise part of the evil there. Anna was born in St. Louis in 1960. Her troubled childhood involved sexual and physical abuse, causing Anna to develop PTSD and other anxiety disorders. She was placed in a state hospital before the age of fifteen and would spend almost two decades being transferred from one state hospital to another. As a result, Anna's mother moved from state to state. Anna possessed amazing artistic

talent, however, and her artwork has since been acclaimed. In 1984, Anna was admitted to Eastern Pennsylvania Psychiatric Institute (EPPI), where she was evaluated and ultimately sent to Byberry.

Anna was twenty-four years old when she arrived at Byberry just before Christmas 1984. In the two years she spent there, her experiences stretched between some of the best in her life to some of the worst. Soon after arriving, Anna was faced with abusive staff, dangerous patients and almost no helpful treatment. She began cutting herself and attempted suicide several times. She was drugged or restrained for days at a time as a result. Anna reported being sexually abused by staff and other patients and spent a lot of time in seclusion. Once a treatment plan for Anna was laid out, her experiences began to improve. More time was spent with Anna, and a more aggressive form of treatment was engaged.

Her artwork was encouraged and became popular at the hospital. Anna became romantically involved with another patient, who had a similar background. The psychologists at Byberry worked well with Anna and were able to diagnose her with PTSD. Anna reported that she was in full agreement with her diagnosis and was working her way out. She maintained a positive attitude and continued to work with staff. Further studies of Anna's behavior suggested she may have had multiple personality disorder. Her treatment involved medications, hypnotherapy and insulin therapy. But Anna was making the most progress she had yet.

By 1986, Byberry's budget was dangerously low. Transfers continued to reduce the patient load but, with it, the staff load as well. Life at the little city of buildings was becoming increasingly perilous. Anna's treatment was beginning to dissolve as more staff abandoned the sinking ship. Her treatment team transferred to other hospitals, and her psychiatrists' workload increased threefold until they, too, finally fled. Anna, with the help of her mother, reported what she witnessed at Byberry to state authorities. The staff resorted back to restraining and secluding Anna. She attempted suicide again and was drugged heavily by staff as a result. Anna, too, finally plunged away from the chaotic shipwreck. In November 1986, Anna and her boyfriend eloped from the hospital and began looking for a place to live in the nearby area.

Anna wound up back in the system, and after spending time in Norristown State Hospital, she escaped and moved to California. While living there with her mother, the death of her grandmother caused Anna to resort to her old behaviors, and she wound up in Napa State Hospital. While there, she reported experiencing further abuse by staff. In November 1992, Anna finally

committed suicide on her ward, ending her traumatic existence and finally achieving piece. For more information about Anna and the charity that exists in her name, please visit www.theannainstitute.org.

Another is the story of Billy Kirsch, which made headlines. William "Billy" Kirsch was a young boy when his father, a single parent, noticed something different about him. His adolescent years seemed to be worse. Peers would tell Billy to get naked and run down the street, and Billy would. And when Billy was diagnosed as mildly retarded in the 1970s, it put his treatment in a precarious position. Billy had a real problem with violent outbursts. He would destroy furniture and walls at home and lash out at his father. The kind of aggressive treatment Billy needed was very expensive, and his father, knowing of Byberry's bad reputation, did his best to avoid putting Billy there. Coming from a working-class family, it became harder and harder to afford treatment for Billy, and in 1980, Billy was committed to Byberry by his father. "When the insurance money ran out," explained Billy's father, William Kirsch Sr., "I had the choice of bringing him home or putting him in Byberry. I brought him home, but after three weeks, I just couldn't keep working."

Billy's time at Byberry was like a whirlwind. It was probably the worst place for someone like him to be. The first few years seemed to improve Kirsch's condition. He received ground parole and was allowed to visit home frequently. But by 1985, his violent outbursts earned him a transfer to Norristown State Hospital. In only one year there, he had proven unmanageable to staff, who refused to keep him any longer. He was transferred back to Byberry, where they took the precaution of using restraints on him a regular basis. When his father visited him in 1986, he was unsettled to see his son in five-point restraints. According to an *Inquirer* article, "He was in bed. Both ankles had leather cuffs on them that were tied to the bedposts. Both wrists had leather cuffs on them that attached to a belt around his waist. Across his chest was another strap."

Albert B. Resnik, a PSH psychiatrist, stated, "To be utterly frank, I have never seen anyone like Billy before—never. We wrack our brain trying to come up with a new idea on how to deal with the symptoms that Billy presents." This proved an understatement. Byberry staff stated that the more Billy acted out, the more they restrained him. But the more they restrained him, the more he acted out and the more violent he became. The staff resorted to restraining him as part of a daily routine. He was let out much less frequently, and the few times he was, he became enraged. In September 1986, Billy was restrained in his bed and not let out for an astonishing fourteen months.

When William heard about his son's treatment, he filed a lawsuit against the hospital. With the landmark suit *Haldeman v. Pennhurst* coming to a close and the spotlight on patient treatment in Pennsylvania, the Kirsch suit did much for Byberry's closure. As Philadelphia civil rights attorney Edmond Tiryak put it, "The story of Billy Kirsch raises questions about what's going to happen to the people of Byberry. The Welfare Department, when it announced it was going to close the place, assured everyone that they would use that money to provide community services. But here we have a situation where they have a guy they admit they've wronged and their solution is to ship him across the state to another institution. They're saying one thing, then, a couple of months later, they're turning their back on this kid." Patients like Billy Kirsch and Anna Jennings became Byberry martyrs. Their stories, tragic as they were yet fatefully timed and immortalized in the flow of the struggle for closure, would help send Byberry back to hell.

In January 1988, as agreed, former assistant superintendent Norman Flaherty moved up into Ford Thompson's vacancy, and Thompson returned to Harrisburg State Hospital. Shortly after his appointment, Flaherty reported that the situation at Byberry was repairable. But apparently after reading the Blue Ribbon report, White had been too deeply sickened and believed Byberry was far beyond repair. "Unfortunately, the legacy of Philadelphia State Hospital, which has been allowed to go on fifteen or twenty years," White said, "is one that I cannot change."

## Left to Vanish

By 1988, Byberry consisted of a skeleton crew. Only a handful of janitorial staff remained, and the maintenance department was down to a few men. Aides and low-wage positions were almost completely gone. Naturally, filling these positions was impossible in light of the looming closure. The staff who remained at this point did so solely out of care for the remaining patients, but a dangerous situation was brewing. On January 2, fifty-eight-year-old patient Lonnie McRiley, missing since December 31, was found frozen to death on the hospital grounds. As a result, staff started a "locked-door" policy for all wards, which amounted to a three-by-five card taped to the door of each ward reading "door must be locked at all times" in black magic marker. Ten days later, on January 12, a second patient was found frozen to death just outside a locked door. The patient, seventy-one-year-old Carmella

Rocco, walked off of the geriatric ward, presumably locked, after dinner the previous day.

It was not hard to blame the hospital after the death of the second patient during a new locked door policy. The policy itself, some argued, actually caused the death of Rocco, as it did little to secure her on her ward. Ironically, the locked doors could not be opened from the outside, and the scarce population of attendants assured that no one knew of Rocco's dilemma. She was found curled up in the snow as if sleeping, wearing only a hospital gown, by a local resident while walking his dog the next day. Although two police officers searched the grounds until their shifts ended, they found nothing. A police investigator commented, "You tell me how someone who supposedly is mentally deficient and seventy-one years old sneaks out of a locked building. That place is huge, and if you don't want to be found, you won't be found. It's so big, and there are so many hiding places you can't cover it all."

Rocco's son settled with the State in December 1988 for $100,000 after he began a lawsuit. But Philadelphians, especially Somerton residents, had had enough of Byberry. They had enough of its stories of horror and the quick rushes to reform that would follow, only to break down, over and over again. Nothing at this point was too shocking. The good residents of the neighboring houses on Carter Road had seen patients on their lawns, in their homes and in their cars. They had found dead patients far too often in their community and were not sympathetic to the state's money problems. They wanted Byberry closed for good. In a January 1988 *Philadelphia Inquirer* article, however, local residents spoke of their experiences while living next to Byberry. They gave mostly positive testimonies, and they all mentioned that they thought the patients were the top priority.

Frank Novak, whose home was only feet from the hospital property, recalled friendly encounters he'd had with patients and the terrible stories they told him about the hospital. One patient told of being extorted monthly by aides for his disability check. Another neighbor, Irene Jones, recalled moving to her Somerton home in 1965: "Back then, the buildings surrounding Byberry were in good shape," she told the *Inquirer*. "Azalea bushes lined the fences, and it was well taken care of." Jones remembered cows grazing in the field on the southeast corner of Southampton Road and Route 1, where the National Guard Armory currently stands. She also remembered seeing patients from her window, cheerfully doing gardening and farm work. But by the 1970s, neighbors began to notice obvious signs of trouble.

"That's when the fences came down. The farming ended across the street. The azalea bushes were removed." Jones reported, "That's when the hospital started to look shabby. Hospital patients were given ground privileges, and you couldn't differentiate between the patients and the aides."

According to Novak, patients became a familiar sight in the neighborhood. Children would yell, "Byberry Alert!" when they spotted a patient. Jones and Novak, both members of community group the Somerton Civic Association, agreed that the closing was the right move but expressed worry about the future of the property. Local residents knew the value of the property and did not want commercial buildings in their neighborhood. They were also concerned with the state's plan of post-institutional care for the patients they had come to understand were in need of serious treatment. They did not want to see more patients wind up on their streets, and they showed little appreciation for the administration's dilemma.

At the same time, the temporary management team that had been put in place at the hospital, like its recent administrations, was dealt a painfully impossible hand. With its funds dropping so significantly, it was totally unrealistic to expect the remaining staff to be able to successfully transfer the population to where each patient needed to be the most. It is not difficult to find sympathy for the remaining staff at this point in their careers. It is fairly certain that they worked as hard as they could to achieve the removal of their patients to proper recipients. Their efforts were largely overlooked by the local media, however, and some attacks on the administration seem, in retrospect, unjustified. The staff that remained after 1987, for the most part, were in it until the end and deserve real praise for their courageous perseverance.

On June 27, 1988, Dr. Donald Daiter, on behalf of Acting Chief of Clinical Services Emmanuel de la Cruz, issued a memo to the treatment team leaders asking them to make a list of patients on their wards who presented "a problem in management" and required a "controlled environment." They were told to "carefully select only the handful of patients in this category" but that this was "not to be construed as 'dumping' or 'getting rid of problems.'" These patients were the ones left who proved the most difficult to transfer, as they required consistent, intensive treatment that the community health system did not provide. There were only a few facilities left in the state for the treatment of dangerous mental patients, and they were too overcrowded to absorb the full load from Byberry, which made up about half of the state's population of this class.

# Not So Fast

The newspapers printed stories favoring both sides of the closure issue. Some joined the cause of keeping Byberry open. *Inquirer* writer F. Lewis Bartlett wrote:

> *The editorial "Closing Byberry" appeared on the same day that the Inquirer carried two related news stories. One was about the awarding of a contract to an architectural firm to design a plan for industrial and commercial development on the 160 acre hospital site and the adjacent 238 acre state park after the hospital is closed. The potential for "big money" to have influenced the "clinical decision" to better serve Byberry's patients in the community is hard to ignore. With public and private facilities, including shelters and boarding houses, unable to care properly for the victims of grave mental disorders, the future for the severely and chronically mentally ill patients looks bleak.*

Bartlett called attention to the fact that Philadelphia had no real backup facilities to which it could transfer the patients. Many on the patients' rights side of the argument now recognized what could become an enormous problem. By putting too much effort into the closing of the hospital and not enough into a plan of post-hospital care, the patients could literally become sacrificial lambs for the achievement of the goal of closure, which was ironically for their benefit. Staff member Michael J. Orezechowski was also against the closing. He cited several instances of patients whom he claimed could not properly function outside of Byberry. Although perhaps a bit biased, his 1989 English thesis reads in part:

> *Shortly after the discharges started, Thomas J. Gibbons Jr. wrote an article in the Philadelphia Inquirer entitled "Woman Hurled in front of Subway." The story was of two people, an ex-psychiatric patient, and an innocent bystander. The ex-patient had been housed and treated at Byberry several times. He had walked off the hospital grounds and after several days was discharged for unauthorized abscence. Later, while standing on a subway platform, the patient pushed a bystander, Ruth Warrington, in front of an oncoming train. He was responding to internal stimuli that told him to push her.*
> *The closing of Philadelphia State Hospital is a tragedy, a tragedy that could have been avoided. Byberry is not being closed due to negligence and*

*abuse. It is being closed because of greed. The undeveloped land is being sold for unknown dollars per acre. When contacted, Philadelphia Industrial Development Corporation (PIDC) refused to give any information, stating it is confidential. If a public institution is being sold, doesn't the public have a right to know the price tag?*

Orezechowski and Bartlett were not alone in this opinion. Many believed there were political implications in the matter. Mayor Wilson Goode had earned a negative reputation after firebombing a city block in the MOVE ordeal, and his enemies tried to paint him as irresponsible for allowing Byberry's closure but not getting too involved in the matter.

## FLATLINE

At long last, on June 21, 1990, the last five of Byberry's patients were released. Two were moved to Community Mental Health Centers, and three went to nursing homes. One patient had lived at Byberry for forty-five years prior to the closing. All five patients and remaining staff were reportedly in tears. The long shutdown process to them was like slowly suffocating a wounded friend or putting down an old dog. When the doors were finally closed and locked by the last of the staff, a sigh of relief was breathed by everyone who was conscious of it, as if they had just buried Hitler. The biggest step ever taken to right the wrongs presented by Pennsylvania's psychiatric care system was complete, and Byberry's ship finally sunk below the waterline.

What remained in the immediate aftermath of the closing was a mix of feelings that ranged from overwhelming joy to utter hopelessness and sorrow. Most who had been involved with Byberry were in agreement that the right move was made; however, not everyone had the same faith in the new system. The scars left behind by Byberry may have finally stopped bleeding, but they were far from healed. The ninety-year-old anomaly of human indignity sucked the rug out from under the feet of its conquerors upon its quick departure from the world, leaving behind a frenzy of ideas on how it should be remembered. It seemed no one was too anxious to memorialize the hole that Byberry left in Philadelphia. The general public's sympathy turned into fear and disgust rather quickly, as the homeless population in the city increased drastically. Now the patients that everyone read about and seemed to feel so sorry for were on their

streets, at their subway stations, in their local fast food restaurants and at their local gas stations, and somehow, up close and personal, they did not seem as worthy of sympathy.

A few months later, after somewhat of a cooling period, focus became narrowed on the reuse of the property. The Philadelphia Industrial Development Corporation (PIDC), a product of the Goode administration, which did not have a completely clean public image itself, had big plans for the property. Industrial parks, housing, a home for veterans and even a skating rink were in the works. When building inspectors and workers began their evaluation of the thirty buildings on the 136-acre property, they revealed that the buildings and tunnels contained asbestos. It was in ceiling and floor tiles, on pipes and in walls. It soon became clear that the buildings could not be reused or torn down without the complete abatement of every building. When estimates reached the eight-digit figure count, the state was forced to put the property's reuse on hold.

Reports from building inspectors also revealed something surely more unexpected. Talk of ex-patients squatting in the buildings surfaced, and police received several early reports of a strange man wandering the hospital grounds. Given the number of patients who had recently been released on their own recognizance and the number of years some of these patients had

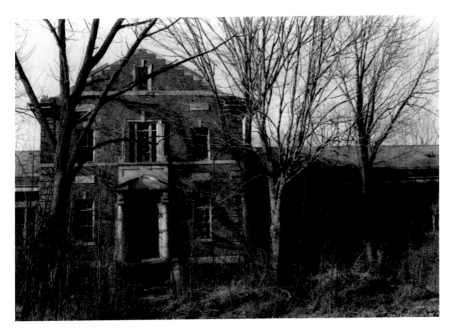

Building B, East Group, circa 1989. *Courtesy James Bostick.*

spent at the institution, it is very likely that a number of ex-patients returned to the only home they ever knew.

For the first time in almost a century, Byberry did not appear in newspaper headlines. The pages seemed naked without the boldly worded summaries of shocking stories accompanied by eye-catching pictures. People could not remember a time when the area was not associated with the hospital. Patients were no longer plowing the fields or strolling the grounds. Nurses and attendants were no longer bustling about multitasking. Dangerous men were no longer escaping through windows. Perhaps most starkly of all, caring groups were no longer investigating the hospital, and no longer were patients suffering in their personal man-made hell. Byberry was silent.

Chapter 8

# THE REDISCOVERY OF A DISCARDED PAST

## *The Years of Abandon*

### Shuttered

The idea of an abandoned mental hospital is a naturally intriguing one and the ideal setting for a horror film. Byberry's ominous presence proved frightening enough in itself to keep most curious explorers out. The daily property patrol, performed by state troopers, helped keep out the rest. But it takes a certain type of person to take an interest in a place like Byberry. Unfortunately, the cavernous safety of Byberry attracted the homeless. The first adventurers to Byberry were copper salvagers and looters, followed by local teens and, of course, ghost hunters. Events from Byberry's horrific past had formed a fearful collage. Somerton residents would never forget the hospital's legend. Although many of these stories have proven to be fact-based, they have become highly exaggerated. The true horror of Byberry is what had already happened there, but don't tell that to the folks of Somerton. They lived only feet from twentieth-century America's most corrupt and notorious mental institution.

The "Byberry Phenomenon" blew so far out of proportion that it became one of the country's most famous haunted places. By 1993, the popular Philadelphia rock radio station Eagle 106 held a haunted house in the old nurses' residences at Halloween for three consecutive years. A large percentage of the profit went to the Self-Help Movement. By 1995, the crumbling structures of the East Group had all been demolished except for one of Byberry's oldest buildings—building C—which has been refurbished

and is in use today (ironically) as a daycare center and office building. In 1997, the warehouses were demolished. In 2000, the west power plant and garages followed. Finally, C-6 and C-12 were torn down by 2001, leaving the laundry building as the only surviving building south of Southampton Road. The early explorers used the laundry building as an easy entrance to the rest of the property. Its steam tunnels provided an easy underground walkway under Southampton Road to the rest of the remaining campus.

It wasn't until about 2002, however, that Byberry reached the peak of its celebrity status. Websites began to emerge telling of the hospital's exaggerated stories. Maps were available with hints on getting in, and even the security company's shifts and driving routes were documented. It didn't take long for even the painfully shy to show up with backpacks and flashlights. Before long, patterns of explorers began trekking through Byberry's dank hallways, and a sub-culture emerged. Many of the "regular" explorers used tag or graffiti names to identify themselves to each other. Byberry was probably as puzzled by this new life within its walls as the people inside them were by Byberry. It was right around this time that I first discovered Byberry.

## THE LAST PATIENT

The first thing I noticed was the smell. As I inched my head into N-10's locker room window, I did not have to go inside to notice it: the smell of abandonment. As soon as I walked a few yards into the thin woods on the edge of the hospital property, the lights and sounds from the houses along Carter Road seemed to disappear completely, like they were never there at all. When I took my first trip to Byberry with my friend Jay, the experience the abandoned environment provided is something I will never forget. What occurred that night was the opening of a door in my mind that will never close again. I had to see every square inch of it. But the more I saw, the more questions I had and the more committed I became to finding answers. It was a vicious circle, and I had no idea what I was getting into.

What remained of Byberry in 2002 was 138 acres of weeds, bushes and large, foreboding buildings, twenty-three of them. There was also most of the original West Group, which looked more like a lost and forgotten colonial town, swallowed up by nature. The North Group also remained entirely. Its '50s-style blocky hulks had once looked like schools or complex-type apartment buildings. Now they looked like a scene out of a post-apocalyptic

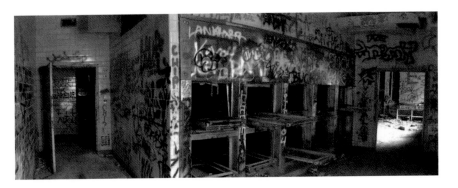

Morgue in N-3 building, 2005. *Photo by author.*

war zone. The solid nature of their structures appeared more startling to me in their abandoned state than the old West Group, which looked literally like something from a horror film. Although clearly creepy in nature, they were something that my eyes had experienced the sight of before, even if it was in a horror film. But the north group, their large façades ever looming above the high weeds and trees, seemed a much more out-of-place and unsettling sight to me. Buildings like that shouldn't be abandoned, I thought. They were so ominous and eye-catching, too. The recently constructed industrial parks and the well-kept homes surrounding the 138 acres of gloom made its presence that much more surreal. People jogged and walked their dogs past it, cars zipped by on busy Route 1, and planes flew overhead frequently coming in and out of the Northeast Philadelphia Airport, but nobody seemed to acknowledge Byberry's presence.

There was really not an abundance of graffiti on the buildings' exteriors in 2002, and they seemed all the more sinister. I returned several times with friends, people from school and basically anyone I could get to go with me. I pushed myself into darker and darker corners, into the closets and bathrooms and then crawlspaces and tunnels. But the questions I had only became more pressing and burning. When I typed "Byberry" into an Internet search engine, I was presented with information that pulled my interest even more. There was no official website, and almost all of the results also contained the phrase "haunted house." Websites made by local teenagers showed crude maps and blurry photographs showing a morgue and an auditorium. This place was really engulfing me now. I contacted the creator of one of the websites and arranged a meet up. The site creator, Jim, was more than happy to enlighten me about the various nicknames some of the buildings had earned by local teens who had been partying inside for years.

Referring to the map he had made of the property, Jim pointed to N-10 first. "This one's called 'infinity,'" he said. It was given this name because of the two large, windowless basement recreation areas the building featured. In the dark, a flashlight was incapable of illuminating the entirety of either of these areas, and they appeared to go on for infinity. According to Jim's map, W-6 was known as "the mortician's building," and W-7 was simply known as "birdshit" due to the copious amounts of pigeon droppings that had accumulated inside. N-9 building was labeled "champ's couch," referring to the giant concrete partition on the roof that was conveniently shaped like a sofa and was a popular gathering point for regular visitors. And of course, W-3 was "the morgue building," calling attention to its most popular feature. It appeared that there was life within this dead environment—a subculture. I was hooked.

Once I saw that there were others who also felt intrigued by the place, my obsession seemed less bizarre. I began taking regular trips to Byberry with friends, sorting through whatever I could find inside—paperwork, photos, patient records and reports. The material left inside the buildings, W-3 especially, was enough to answer some of the questions that had been bouncing around in my head, such as each building's designated purpose. They had all seemed out of place to me, just a random collection of weird buildings. But when I learned their purpose and layout, my intrigue only doubled. I had never had much interest in the past. My sense of history was a cloudy mess. Byberry was my doorway into what has become my passion.

By 2003, Byberry was overrun by a large number of regular visitors, as well as "newbies" pouring in every day. Some remained loyal "Byberrians," and others couldn't wait to get out. It was an environment unlike anything else. People's lives connected through the experience of going to "the berry" religiously. It was a place with no law, no church, no last call and no admittance fee. Trespassers took full advantage of the un-governed metropolis. The connecting hallways provided easy passage between all the buildings, and the police rarely attempted to pursue trespassers. It was a place the city and state wished would just disappear.

In March, my friend Will and I were exploring W-3 building. I was taking photos of the graffiti-covered staff auditorium. Then, from the hallway came the faint sound of broken glass under someone's feet. Will and I stopped in our tracks. Standing in the middle aisle, I stared out into the hallway, not blinking. The reflection of the setting sun shone into the marble-lined lobby at the end of the dark hallway, about twenty-five feet away. The gleaming reflection of sunlight on the marble wall danced around as the trees outside

filtered its flow. The crunching got louder, carrying muddled voices with it. Someone was coming down the hallway. Girls were laughing. We avoided the other visitors, but it wasn't long before I met literally hundreds of explorers. After that night, the last of my fear diminished, and in its place, my obsession grew.

I began visiting Byberry on a weekly basis, collecting artifacts and putting pieces together. The exploration of the buildings became like a real-life video game to me, and I started getting good at it. I began getting answers to my questions, and the bizarre abandoned snake pit began to make sense as a working physical plant. After half a decade of a truly unique and incomparable experience, I am proud to call myself a "Byberrian." The times I spent within its walls were some of the best I've ever had. But in March 2006, the Westrum Development Corporation purchased the 106-acre Byberry site. Pressured from Somerton residents to end the "Byberry problem," Westrum moved quickly. In April, the "Berry" was frequented daily by the regulars, but when June began, things halted. By June 7, there was a chain-link fence surrounding the property. And not a week later, truckloads of trees and other natural growth clinging to the buildings were removed and discarded.

## BYE-BYE BYBERRY

The original West Group, for the first time in twenty-five years, boldly displayed its architectural pride. On June 14, 2006, a celebration of sorts was held in front of building C-7 to commemorate the long-overdue demolition of the neighborhood eyesore. The overgrown hospital sign was ceremoniously knocked down. In attendance were Governor Ed Rendell, Mayor John Street, CEO J. Westrum and J. Sweeny, CEO of Brandywine Realty Trust, the developers of the new buildings to be built onsite. At this writing, still unfinished homes for fifty-five and older residents cover the site, but portions of the hospital's roadway system are still in place. Other traces still loom of Byberry's existence. In wooded areas near the hospital, building remains and PSH-stamped patient clothing can still be found, dumped from earlier demolitions.

Byberry's story—ignored by many, misunderstood by most—has been almost forgotten. It was one of the most tragic and emotional stories that I have ever experienced. For me, the intrigue was in the way information

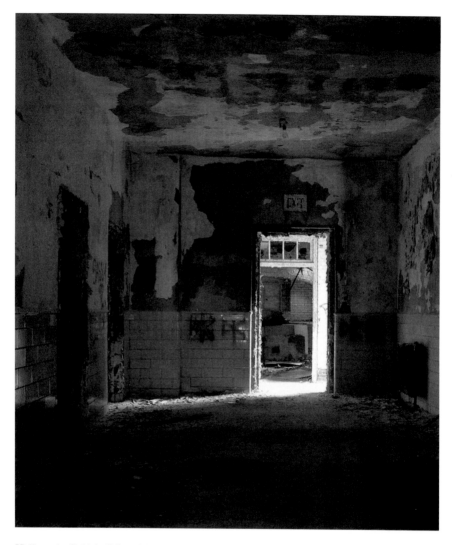

Hallway in C-11 building, 2005. *Photo by author.*

presented itself. The despair seemed endless, a pain that was unfathomable. I hope this story brings awareness of the American pastime of segregating, labeling and ultimately banishing its randomly prejudged classes of citizens. Thank you for reading!

# SOURCES

## NOTES ON SOURCES

All *Evening Public Ledger* articles are property of the Library of Congress, Chronicling America: Historic American Newspapers Site, found at http:// chroniclingamerica.loc.gov.

All *Philadelphia Inquirer* articles are property of the *Philadelphia Inquirer*.

All *Evening Bulletin* and *Northeast Times* articles cited are property of Temple University, Urban Archives- Special Research Collection.

All PA State Archives photos from:
Pennsylvania State Archives, Harrisburg; Record Group 23, Records of the Department of Public Welfare; Philadelphia State Hospital; Graphic Material of Philadelphia State Hospital Grounds, Facilities and Activities (series #23.644, accession #4682).

PhillyHistory photos courtesy of *PhillyHistory.org, a project of the Philadelphia Department of Records.*

# SOURCES

## CHAPTER 1

Agnew, David H., Lewis P. Bush, Roland G. Curtin, Charles K. Mills and Alfred Stille. *History and Reminiscences of the Philadelphia Almshouse and Philadelphia Hospital.* Philadelphia: Detre and Blackburn, 1890.

*American Architect and Building News.* September 2, 1905; October 21, 1905; October 28, 1905.

Dudley, Albert W., and Joseph C. Martindale. *A History of the Townships of Byberry and Moreland, in Philadelphia, PA: From their Earliest Settlements by the Whites to the Present Time.* Philadelphia: George W. Jacobs & Co., 1901.

## CHAPTER 2

Annual Report of the Department of Health and Charities for the Years Ending December 31: 1903, 1904, 1906, 1908, 1910, 1911, 1912, 1915, 1916, 1917, 1918, 1920, 1921. Department of Public Health and Charities, City of Philadelphia.

"Awaits Plans for Insane Hospital." Unknown newspaper, 1910.

"Boss Durham Dies at Dining Table." *New York Times,* June 29, 2009.

Forty-third Annual Report of the Board of Public Charities. City of Philadelphia, 1913: 126–130.

Jones, Alfred. "Farm Treatment for the Insane." *Technical World Magazine* XIX, no. 4, June 1913.

## CHAPTER 3

"Architects Will Probe Career of Philip H. Johnson." *Evening Public Ledger,* January 7, 1915.

"Byberry Insane Hospital to U.S." *Evening Public Ledger,* July 20, 1918.

"Byberry Loses Contract for U.S. Men's Care." *Evening Public Ledger*, December 24, 1919.

"Byberry Ready Aug. 1 to Relieve Blockley." *Bulletin*, April, 1916.

"Byberry 'Rush Work' Costs City $185,000." *(likely) Evening Public Ledger*, 1915.

"Dr. Krusen's Farm at Byberry Makes Soldiers of Boys." *(likely) Evening Public Ledger*, 1917.

"Hospital Work Held Up." *Bulletin*, December 30, 1916.

"'Phil' Johnson and his Wonderful Job." *Evening Public Ledger*, January 7, 1915.

"Plans to Question Legal Status of Johnson Contract." *Evening Public Ledger*, January 13, 1915.

"Warburton Charges Byberry Raid." *Philadelphia Inquirer*, July 10, 1914.

# CHAPTER 4

Annual report of the Philadelphia Hospital for Mental Diseases and the Philadelphia Institution for Feeble-Minded, Byberry, Pennsylvania. Department of Public Health, Bureau of Hospitals, Philadelphia City Archives, 1925.

"Byberry Cellar Traced to WPA." *Northeast Times*, April 30, 1970.

"Byberry Faces Menace of Fire and Epidemic." *Bulletin*, March 28, 1930.

"Byberry Hospital to Open Cottages." *Bulletin*, February 20, 1925.

"Byberry Hospital Probe is Started." *Chester Times*, January 21, 1931.

"Byberry Hospital Without Any Head." *Bulletin*, November 16, 1929.

"Byberry Transfer Ok'd by Senate." *Bulletin*, September 14, 1938.

"Curb on Johnson as Architect Asked." *Bulletin*, March 21, 1932.

"Dr. Sands to Head Byberry Hospital." *Bulletin*, November 18, 1929.

"Dr. Sands Regrets Removal of his Aid." *Bulletin*, January 5, 1931.

"Great Work Being Done for Mental Cripples at City's Fine Hospital on Lincoln Highway." *Trenton Sunday Times Advertiser*, March 22, 1925.

"Injunction Issued as State Takes Byberry Over." *Bulletin*, October 15, 1938.

"Injunction Lifted on Byberry Shift." *Bulletin*, October 21, 1938.

"Johnson Contract Fight is Started." *Bulletin*, March 22, 1932.

Mackey, Mayor Harry A. "Report of proceedings at a meeting in the Mayor's room Tuesday March 31 1931 in connection with the survey of conditions at the Philadelphia Hospital for Mental Diseases at Byberry." *Bulletin* archives, Temple University, Urban Archives.

"Mayor Breaks Byberry Ground." *Bulletin*, August 30, 1935.

"Mayor to Dismiss Zimmerman from Post at Byberry." *Bulletin*, June 8, 1938.

"Mayor to Renew 'Authority' Plea." *Bulletin*, May 31, 1938.

"Mayor Will Fire Dr. Zimmerman at Byberry." *Bulletin*, June 7, 1938.

"Men at Holmesburg Don't Get a Chance, Inspector Charges." *Evening Public Ledger*, December 7, 1922.

"Monaghan Probes Rum at Byberry." *Bulletin*, January 7, 1931.

"New Morgue Law Brings Complaint." *Philadelphia Inquirer* or *Bulletin*, circa 1920–1925.

Obituary of Philip H. Johnson. *Chester Times*, November 30, 1933.

"Phila Stirred Over Byberry Insane Cruelty." *Chester Times*, July 22, 1938.

"Public Refused to Believe the Truth about Byberry." *Philadelphia Record*, June 4, 1938.

"Shapiro Byberry Inquiry Near End." *Bulletin*, June 6, 1938.

"Shapiro Says Give Byberry to State." *Bulletin*, July 3, 1938.

"Victims of Maniac Unaware of Death." *Bulletin*, May 17, 1938.

"Will Not Continue Hospital Dispute." *Bulletin*, November 11, 1929.

"Wilson Demands Resignation of Byberry Staff." *Bulletin*, July 21, 1938.

## CHAPTER 5

Abbott, Norman. "The 'Why' at Byberry." *Philadelphia Record*, March 28, 1941.

"Bill in Assembly for Taking Over of PA Hospitals, Goes to Earle." *Inquirer*, September 28, 1938.

"Byberry Chief Wants Dorm to Halt Escapes." *Bulletin*, May 2, 1962.

"Byberry Is Not Fit to Be 'Hospital' Woolley Says." *Bulletin*, December 24, 1938.

"Byberry to Start Remodeling Job." *Bulletin*, May 30, 1954.

"Byberry's Death Rate 8 a Week." *Bulletin*, February 14, 1941.

"Doctors Urged to Aid Mental Institutions." *Pittsburg Post Gazette*, October 21, 1954.

"Dr. Woolley Quits as Byberry Head." *Bulletin*, July 14, 1941.

Ellis, Paul F. "Byberry Tour Reveals Some Defects but Improvements Go Forward." *Bulletin*, January 14, 1941.

"Fatal Beatings Under Inquiry." *Pittsburg Press*, January 12, 1941.

"4 Attendants at Byberry Held." *Chester Times*, April 3, 1941.

Harris, Allen W. "Medieval Pesthouse Disappearing." *Evening Public Ledger*, March 8, 1939.

"Head of Byberry Says B Building Still Is Disgrace." *Philadelphia Record*, February 10, 1946.

Hill, Robert F. "$3,000,000 Byberry Building Will Be Put Up by State." *Bulletin*, January 28, 1947.

Leonard, Gus. "Melodies for Mental Cures." *Boston Herald*, September 10, 1939.

"Low Bids Announced for Work at Byberry." *Bulletin*, January 23, 1948.

"Martin Appoints Dr. E.L. Sielke as Byberry Head." *Record*, February 21, 1946.

"Names Woolley as Byberry Head." *Bulletin*, October 21, 1938.

"New Byberry Head Appeals for Help." *Bulletin*, March 5, 1941.

"New Head of Byberry Had Decided Upon Career When He Was 12." *Bulletin*, September 4, 1941.

Nolan, Joseph. "$1,000,000 Furey Ellis Auditorium Dedicated at Byberry Hospital." *Inquirer*, May 2, 1957.

"No Shakeup Now at Byberry." *Bulletin*, October 22, 1938.

"Ominsky Orders Byberry Probe." *Bulletin*, November 5, 1954.

O'Neil, Thomas. "Byberry Given $5,850,000, Architect to Get 6 P.C. Fee." *Philadelphia Record*, January 28, 1941.

"Patient from Byberry Terrorizes Auto Camp." *Bulletin*, April 4, 1946.

Shapiro, Joseph. "WWII Pacifists Exposed Mental Ward Horrors." *NPR News*, December 30, 2009.

"$27,583,300 Outlay at Byberry Urged." *Bulletin*, January 8, 1941.

"Woolley Defends Byberry Record." *Bulletin*, January 7, 1941.

"Zeller Named New Head of Byberry." *Chester Times*, July 25, 1941.

## CHAPTER 6

Bennett, Ralph K. "Overcrowded Byberry Strives to Foster Hope Amid Misery, Ugliness." *Inquirer*, February 14, 1965.

Brooten, Gary. "Daily Crises Confront New Director at Byberry." *Bulletin*, January 19, 1967.

"Buckingham Alarmed by Mental Camp." *Bulletin*, November 12, 1967.

"Byberry Renews Use of Camp Wonderland for Patient Therapy." *Bulletin*, April 28, 1968.

Cooney, John E. "'Snakepit' Byberry's Worst." *Inquirer*, December 31, 1967.

Daughen, Joseph R. "State to Build 2 New Units at Byberry." *Bulletin*, June 23, 1968.

"Dr. E.L. Sielke Retires as Byberry Hospital Head." *Bulletin*, November 13, 1965.

Dunphy, Joseph. "City Sees Byberry as Municipal Park Site." *Inquirer*, August 10, 1972.

Eichel, Larry, and William Weisenbach. "Missing Patient Is Found Dead." *Inquirer*, June 7, 1975.

Ellis, Lisa. "New Head Appointed at Byberry." *Inquirer*, January 7, 1988.

———. "State Park Lies in a State of Limbo." *Inquirer*, July 26, 1987.

"Ex-Patient Finds a Home in Byberry Tunnels." *Bulletin*, March 6, 1970.

Gemperlein, Joyce. "Ex-Psychiatrist Fights Life Sentence." *Inquirer*, October 24, 1981.

Gunter, David, and Michael E. Ruance. "8-Member Byberry Board Resigns Over Demotion of Hospital Head." *Bulletin*, November 25, 1980.

Herskowitz, Linda. "Judge Refuses to Block Transfers from Byberry." *Inquirer*, October 25, 1981.

Infield, Tom. "State Repeats Offer to Move Inmates Out of Byberry." *Inquirer*, April 3, 1986.

Kanaley, Reid, John Woestendiek, and Susan Fitzgerald. "At Health Centers Locally, Workers Strike and Supervisors Scramble." *Inquirer*, January 23, 1986.

Kearns, George L. "Unit Urges Probe of State Hospital." *Bulletin*, December 16, 1965.

Kohler, Saul. "Probers Accuse Byberry Ex-Chief of Lax Security." *Inquirer*, November 14, 1965.

Lewis, Maurice M., Jr. "Byberry Chief Confirms Plan to Close 3 Chapels." *Bulletin*, October 23, 1973.

McGuire, Arthur M., Jr. "Boys Play on Byberry Grounds." *Bulletin*, August 6, 1970.

"New Lighting Project Begun for Byberry." *Inquirer*, February 19, 1968.

Obituary of Catherine Yasinchuk, *Inquirer*, February 16, 1983.

Obituary of Earline L. Houston, *Inquirer*, June 27, 1986.

"Old Building Is Nailed Shut at Byberry." *Bulletin*, June 30, 1968.

Smyth, Jack. "Self-Help Called Key for Addicts." *Bulletin*, November 26, 1978.

Spady, Mary H. "Patients Can Now Obtain Clothing at Modern Shop in Byberry Building." *Northeast Times*, May 15, 1969.

"State Hospital at Byberry Faces 'Another Trying, Turbulent Year.'" *Bulletin*, February 3, 1974.

Woestendiek, John. "Classes for Retarded Offer Skills to Survive." *Inquirer*, June 29, 1983.

————. "N.E. Mental Hospital To Be Examined." *Inquirer*, May 7, 1987.

————. "Suit Challenges Release of Mentally Ill." *Inquirer*, July 7, 1984.

## CHAPTER 7

"Anna's Institutional Years." www.theAnnaInstitute.org.

Bustos, Sergio. "Relief, Worry in Goodbye to Byberry." *Inquirer*, January 7, 1988.

Detjen, Jim. "Byberry Expected To Be Closed." *Inquirer*, December 6, 1987.

Ellis, Lisa. "Four Aides Fired in Byberry Abuse Probe." *Inquirer*, November 22, 1987.

Miller, Bill, and Mark Fazlollah. "Byberry To Close By 1989, Patients To Be Shifted Elsewhere." *Inquirer*, December 8, 1987.

Orezechowski, Michael J. "The Closing of Philadelphia State Hospital." English thesis, school unknown, 1989 (material found inside building N-3 in March 2003).

"PA to Pay $100,000 in Freezing Death of Patient." *Bucks County Courier Times*, December 31, 1989.

Woestendiek, John. "Byberry Lockup Policy Fails to Prevent Second Death." *Inquirer*, January 12, 1988.

————. "Father Seeks to Free his Son from the Straps of Byberry." *Inquirer*, January 25, 1988.

# INDEX

**A**

Ashbridge, Samuel  24

**B**

Barr, Dr. Everrett S.  52, 54, 59
Blain, Dr. Daniel  121, 125, 130
Blockley Almshouse  18

**C**

Cairns, Dr. A.A.  59, 60, 61, 65
Casey, Robert  145, 147
Clarke, Dr. Franklin R.  122, 130, 136
conscientious objectors  101

**D**

Department of Public Health and
       Charities (DPHC)  23, 26, 28, 33
Durham, Israel W.  24, 27, 36, 40

**E**

Earle, George  88, 90
Ellis, Furey  89, 107, 109, 110, 115
Engard, Charles I.  83, 88
Erb, Dr. C. Charles  140, 146

**G**

General State Authority (GSA)  94,
       101, 107, 111, 115, 118, 127

**H**

Hamilton, Dr. Samuel W.  51
Holmesburg Prison  26, 89, 140
Houston, Dr. Earline  138

**J**

Jackson, Dr. Jeffrey A.  35, 36, 51
Jennings, Anna Caroline  147
Johnson, Philip H.  25, 27, 28, 31, 37,
       38, 39, 40, 41, 43, 45, 47, 48,
       58, 60, 64, 69, 70, 72, 74, 94

**K**

Kirkbride, Dr. Thomas S.  19, 39
Kirsch, William  149
Krusen, Dr. Wilmer  28, 41, 46, 48, 60,
       71, 90

**L**

Lord, Charles  102

## M

Mackey, Harry A.  59, 61, 64, 68, 70
Moore, J. Hampton  42, 50, 57, 70, 74

## N

Neff, Dr. Joseph S.  30, 31, 38

## P

Parker, Mac  75
Pennhurst State School  37, 41, 83, 90,
    150
Pennsylvania Hospital  16, 18, 19, 41
Pepper, George W., Jr.  94, 96, 101, 107

## R

Rickert, Dr. Wilbur P.  77, 81, 83
Rush, Benjamin  16, 17, 133, 135

## S

Sands, Dr. James P.  61, 64, 68, 69, 70,
    75, 77, 79, 89
Self-Help Organization  135
Sesquicentennial Exhibition  57
Shapiro, Harry  75, 80, 81, 87, 94, 115
Sielke, Dr. Eugene  100, 105, 106, 110,
    112, 115, 118, 120
Smithkline French Company  110
Stern, J. David  75, 80, 87, 93

## V

Vare, William  36, 47, 52, 58, 70, 87

## W

Weaver, John  25, 27, 28, 30
Wilson, S. Davis  67, 75, 77, 81, 83, 87
Wonderland Day Camp  125
Woodhaven Center  127
Woolley, Dr. Herbert C.  83, 88, 90, 91,
    93, 96, 100
Works Progress Administration (WPA)
    72, 75, 95

## Z

Zeller, Dr. Charles A.  83, 100, 101,
    105, 106

# ABOUT THE AUTHOR

John Webster is an avid Philadelphia historian, amateur photographer and urban explorer. His photos have been published in the *Northeast Times*, *City Paper*, *Philadelphia Inquirer* and the *Germantown Crier*. More at: http://www.PhiladelphiaStateHospital.com.

*Photo by Ed Straddling.*